Cats in Snow

Cats in Snow

The Ultimate Collection

BLACK & WHITE PUBLISHING

First published 2016
by Black & White Publishing Ltd
29 Ocean Drive, Edinburgh EH6 6JL

1 3 5 7 9 10 8 6 4 2 16 17 18 19
ISBN: 978 1 78530 060 8
Text © Black & White Publishing 2016

The publisher has made every reasonable effort to contact copyright holders of images in this book. Any errors are inadvertent and anyone who for any reason has not been contacted is invited to write to the publisher so that a full acknowledgment can be made in subsequent editions of this work.

A CIP catalogue record for this book is available from the British Library.

Typeset by Creative Link, North Berwick

Images used on p6, p12, p18, p20, p22, p23, p28, p30, p34, p36, p40, p42, p46, p47, p48, p58, p62, p66, p68, p73, p74, p76, p84, p88, p90, p94, p102, p104, p108, p112, p114, p116, p120, p127, p128, p130, p132, p135, p138, p140 © Shutterstock

Images used on p2, p4, p8, p10, p11, p14, p16, p17, p24, p26, p29, p32, p35, p38, p41, p44, p50, p52, p52, p54, p56, p59, 60, p64, p65, p70, p72, p78, p80, p81, p82, p86, p89, p92, p96, p97, 98, p100, p105, p106, p110, p111, p118, p119, p122, p124, p126, p134, p136 © iStock

Introduction

During the winter months, cats are more likely to be found curled up on a chair than outside in the snow. They like the finer things in life – a warm fire, a soft bed, milk at precisely room temperature, and their owner's complete and undivided attention. But things are about to change.

Cats in Snow captures cats as you've never seen them before. From tortoiseshells to tabby cats, feisty felines to curious kittens, they're all in . . . you guessed it, snow! Whether they're up trees, under parked cars or buried up to their necks, this collection sees cats at their most majestic and adventurous.

This uplifting collection features over one hundred stunning photographs of cats of all shapes and sizes, stripes and spots. But while some of them learn to love the snow, others have clearly had quite enough of it, thank you. Enjoy them all in this unique and heart-warming insight into the life of our regal furry companions. They may be out in the snow, but these cats will truly warm your heart.

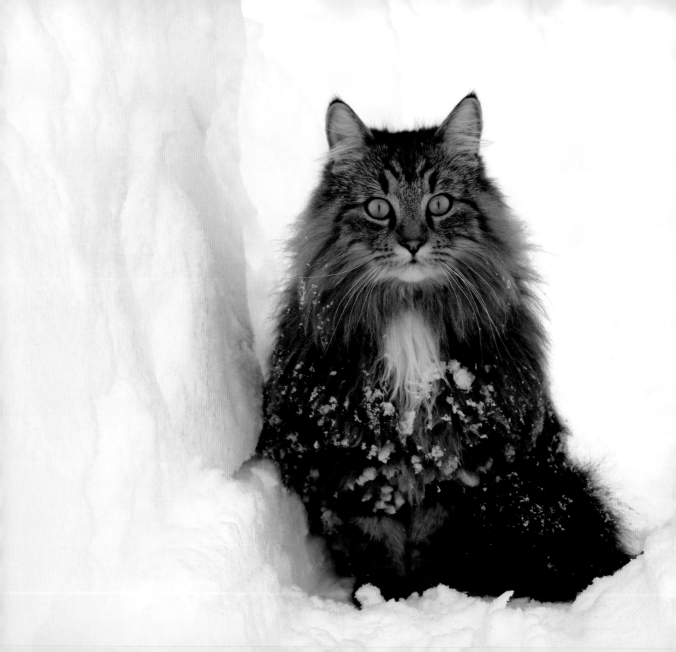

That feeling when you forget to include a door in your snow fort

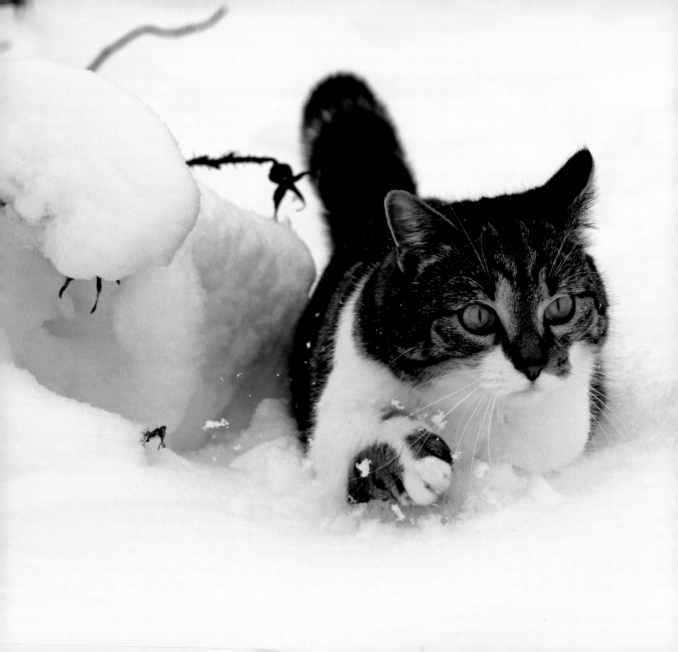

Those snow
boots might
have been a
good investment
after all

The first sign of
snow really brings out
the Grinch in me!

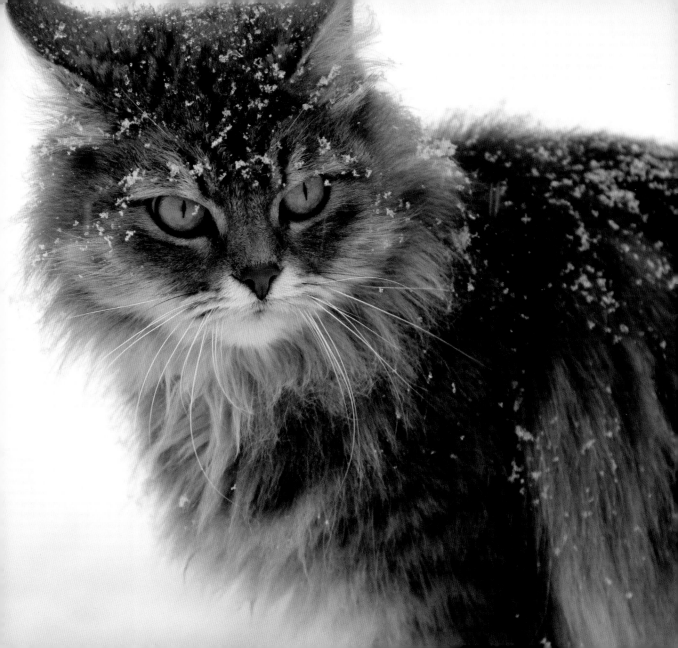

Would I be stupid
enough to try
eating snow?!

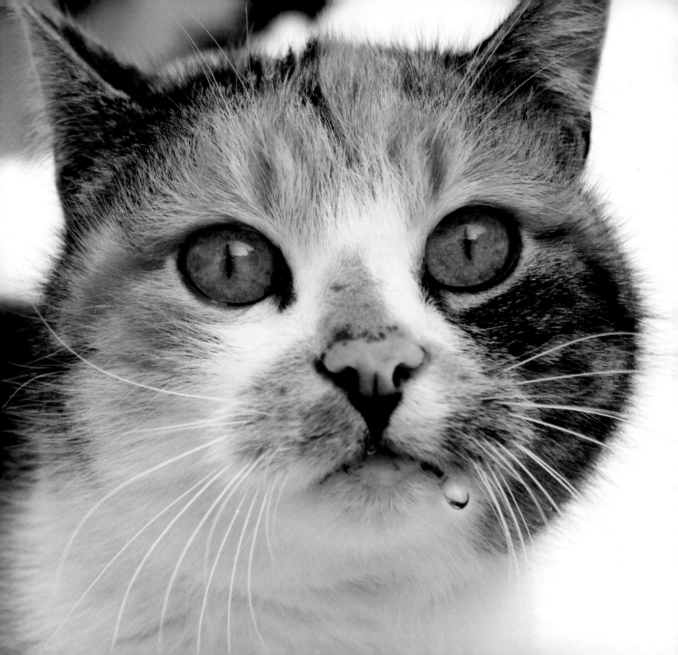

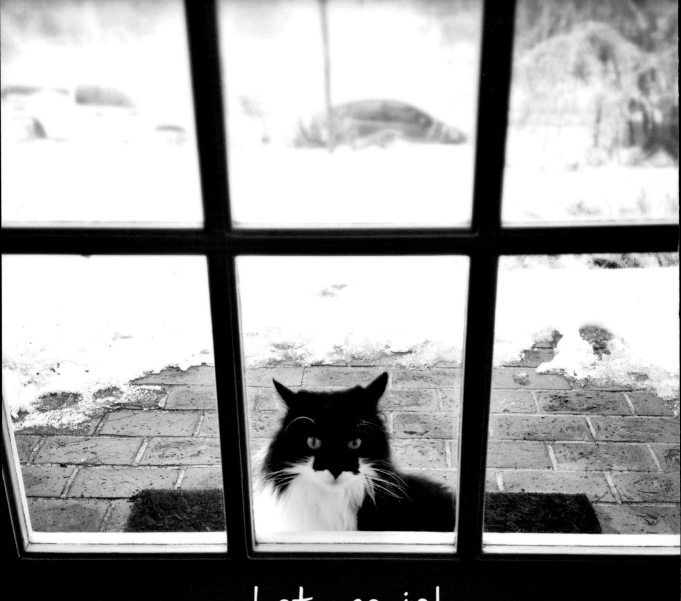

Let me in!

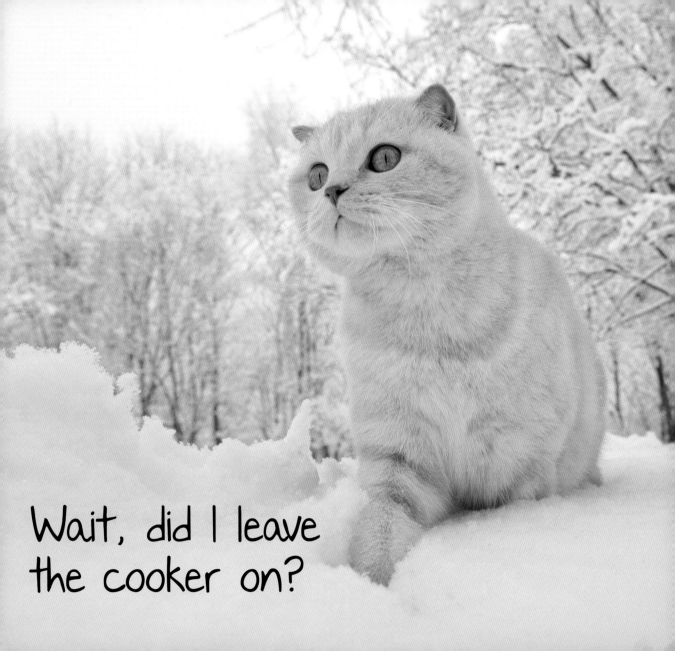

Wait, did I leave
the cooker on?

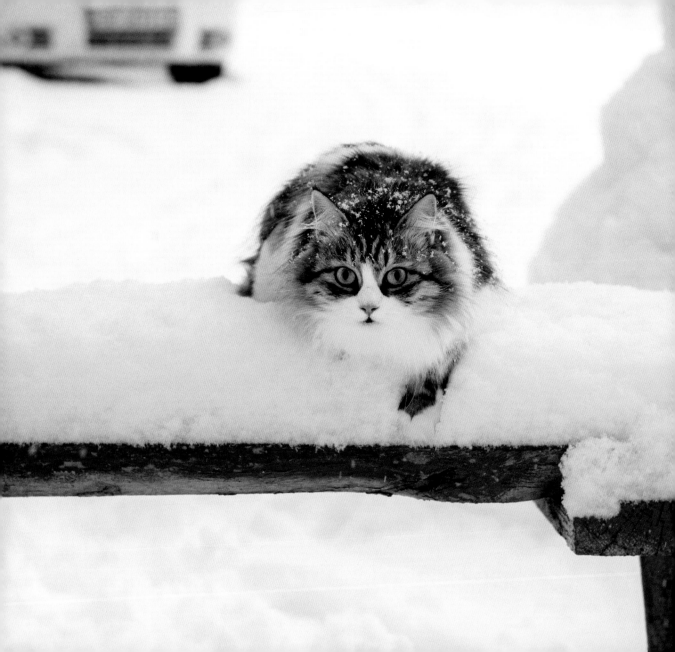

I would move but
my legs are numb

I'm ready
to go
home now

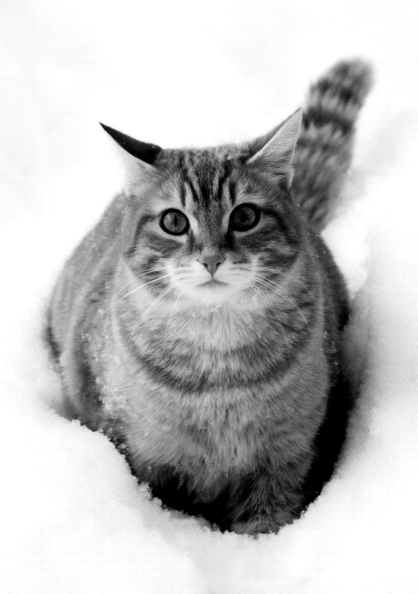

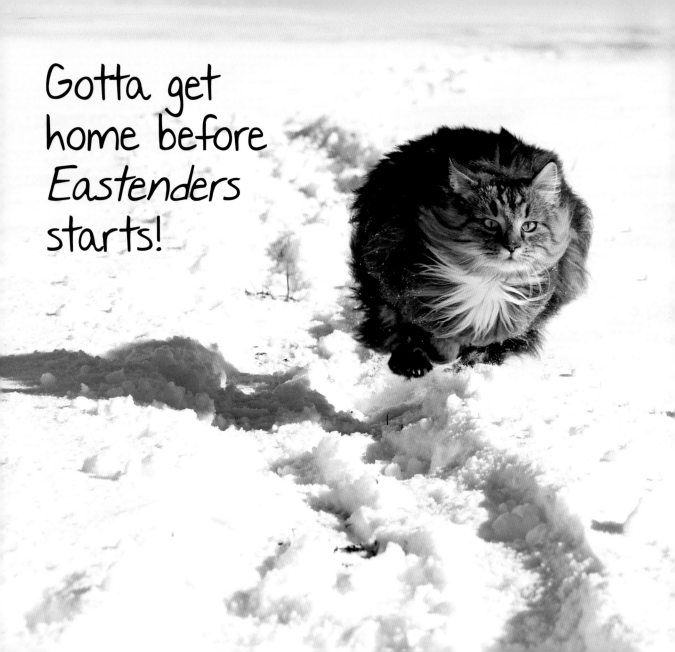

Gotta get home before *Eastenders* starts!

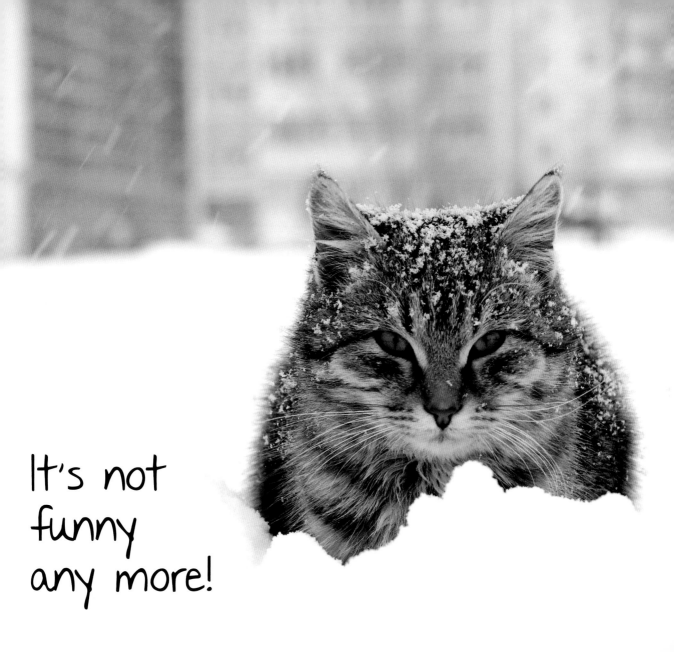

It's not
funny
any more!

I said
DON'T
touch the
yellow snow!

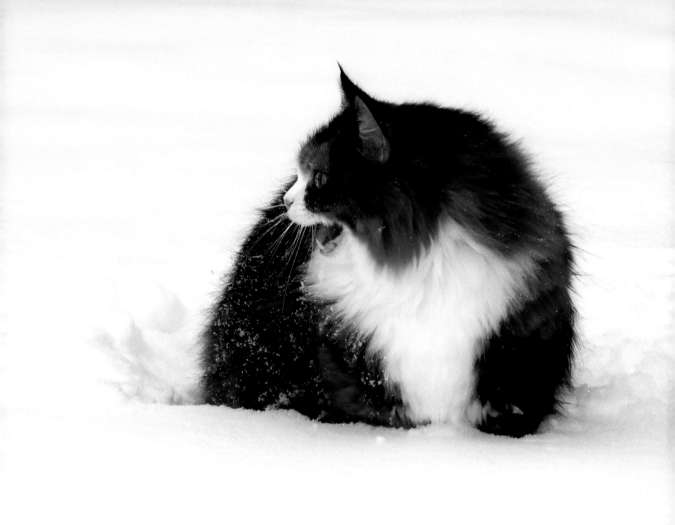

Nope, nope,
nope, nope,
nope, nope

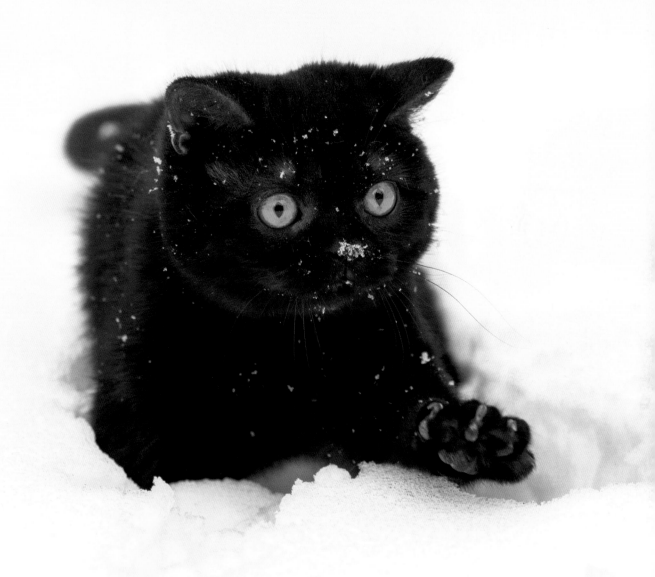

Is it time for apres-ski now?

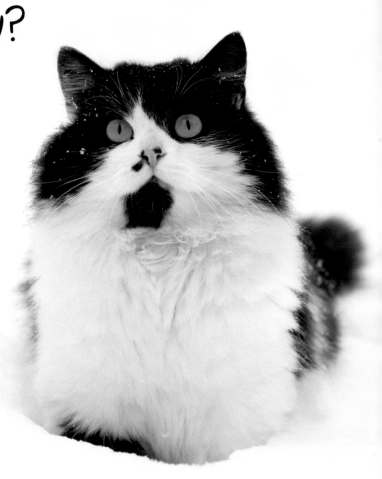

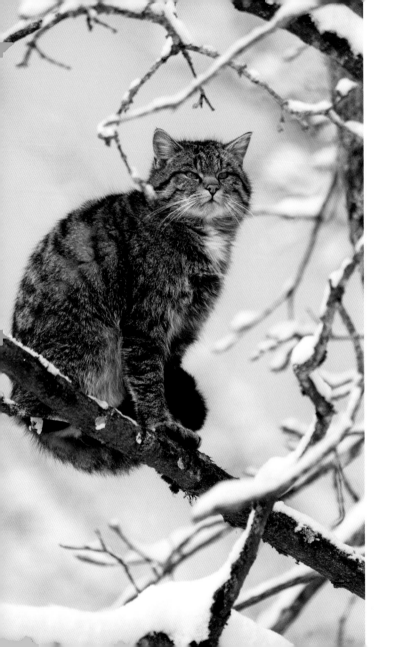

Well, this
is a
worryingly
thin branch
to sit on

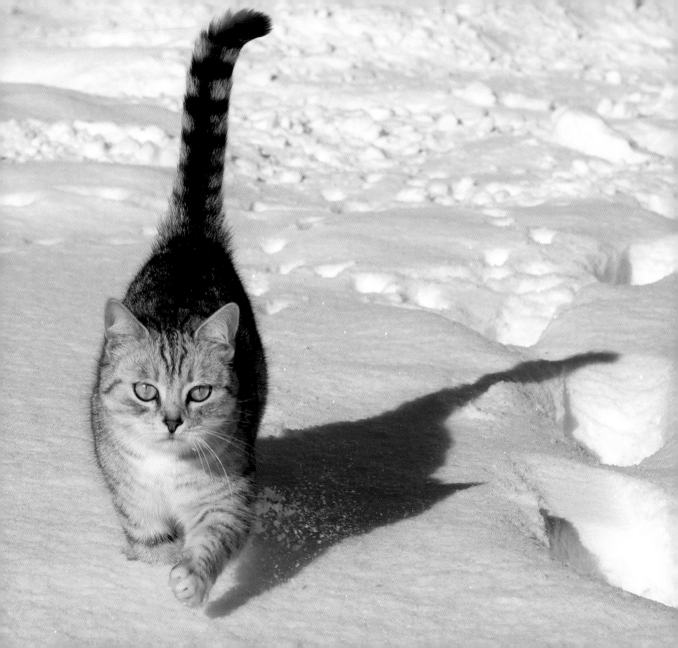

I'm not the kind
of cat that sticks
to the beaten
track, you know?

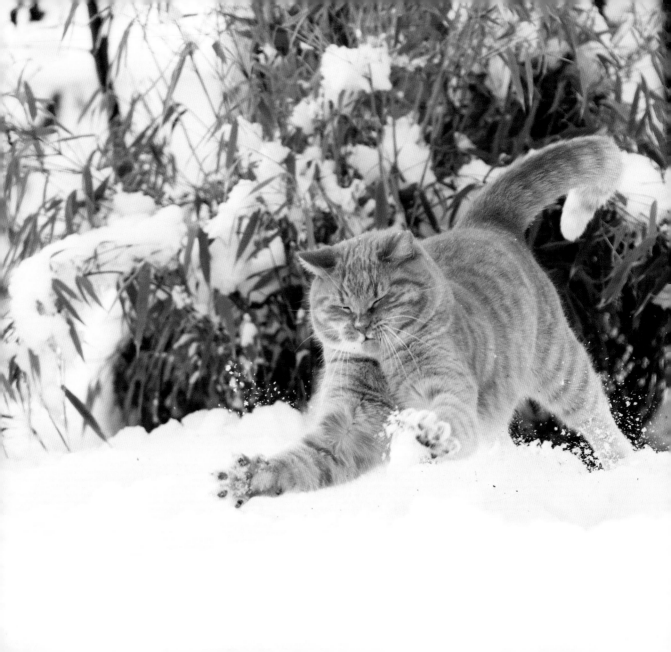

Even if it takes me all day, I'm gonna build a snowman!

I promise I
won't scratch
any furniture,
if you just
let me in...

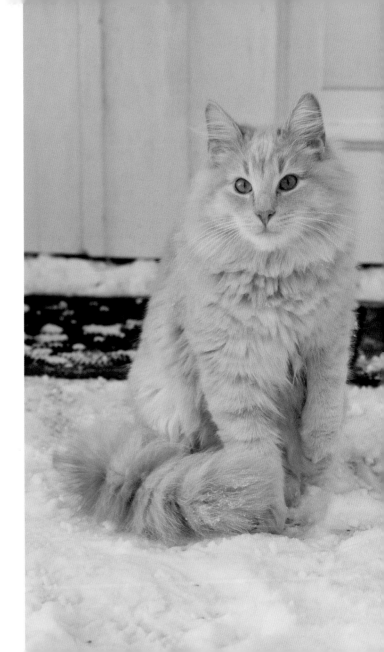

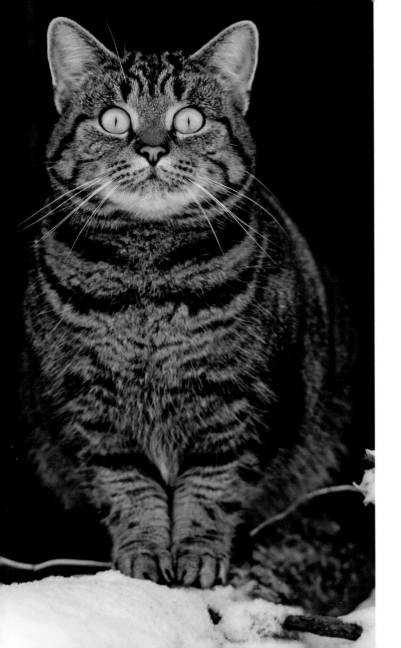

The snow
can
indeed be
overwhelming
for many
cats

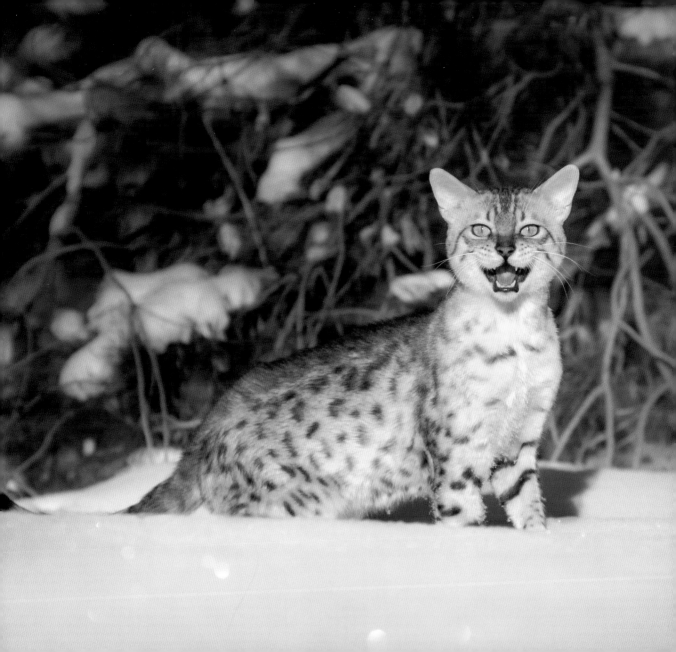

Did somebody say
'SNOW DAY'?!

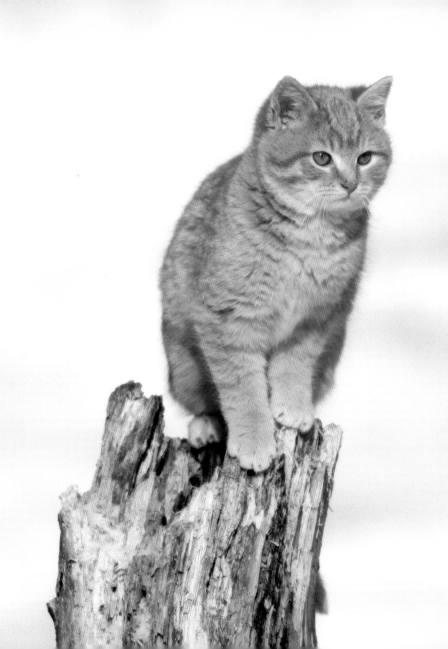

I'm not coming down
from here for the
rest of the winter

I don't care if the snow really
brings out the colour of my eyes

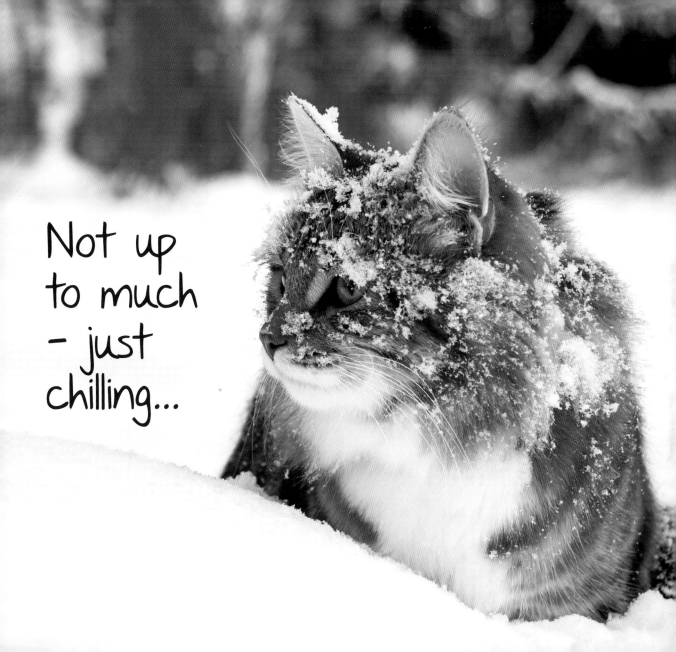

Not up
to much
- just
chilling...

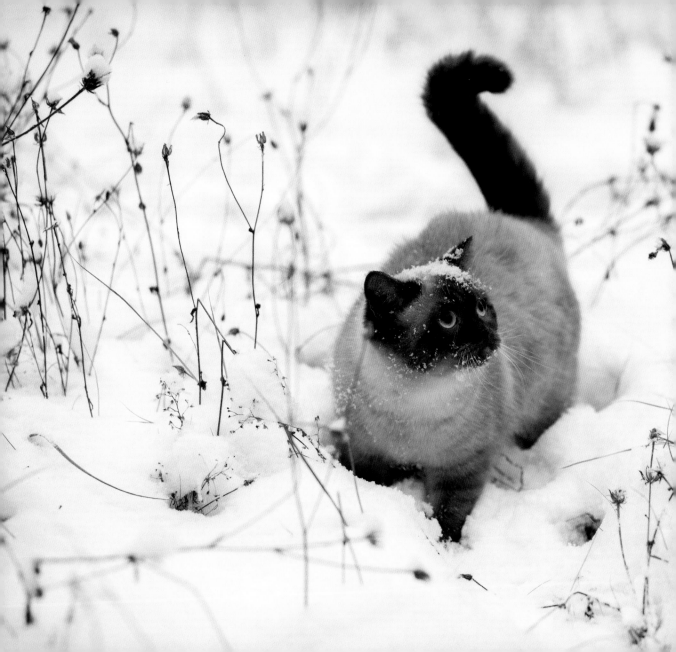

No, no, really it's fine. You just stand there, I'll do this all by myself

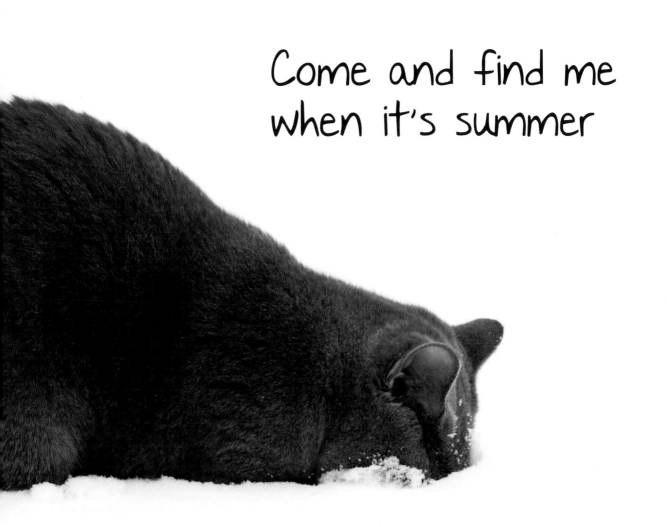

Come and find me
when it's summer

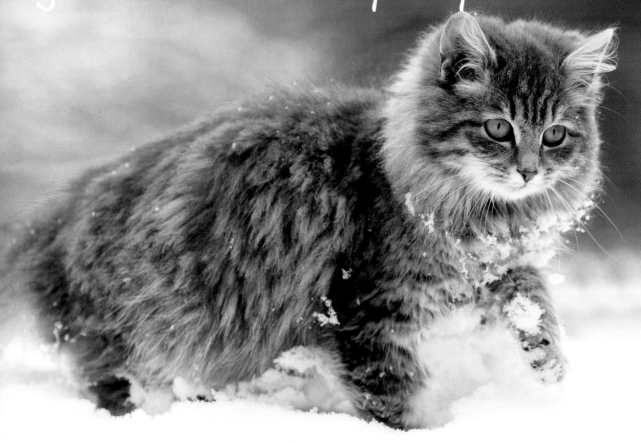

A few inches of snow is not gonna stand in my way!

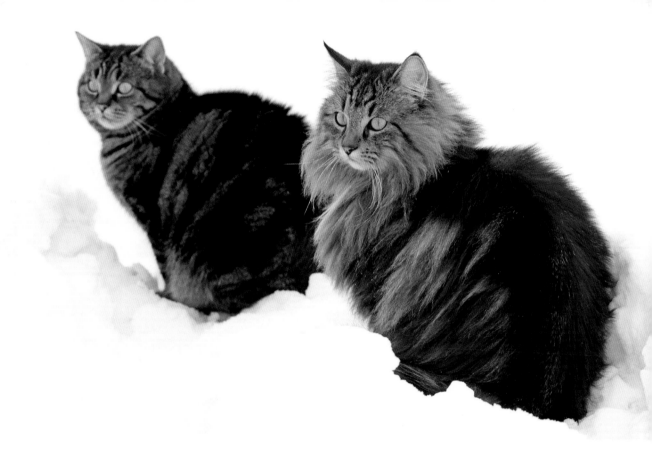

So it all looks the same and it's
all freezing? Hmm.
You wanna go home?

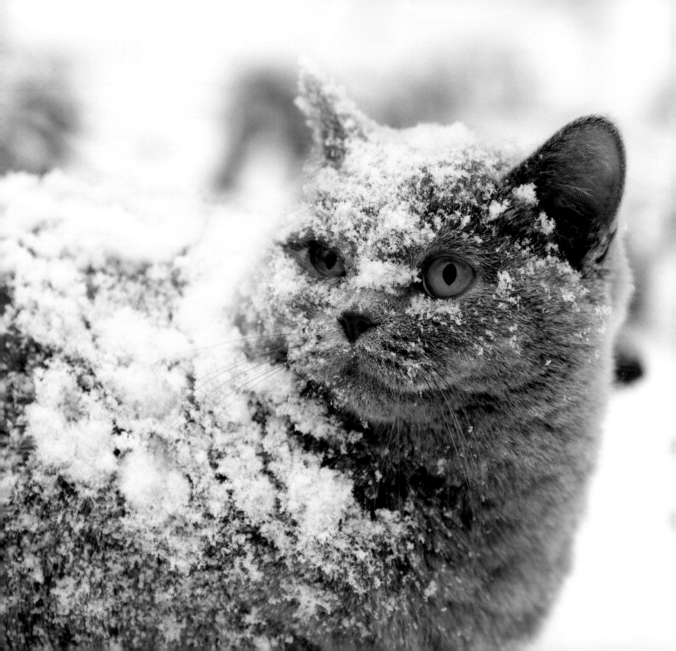

Ok, who threw that?

Adorned in his winter coat, the snow is no trouble for this furry yet fashionable feline

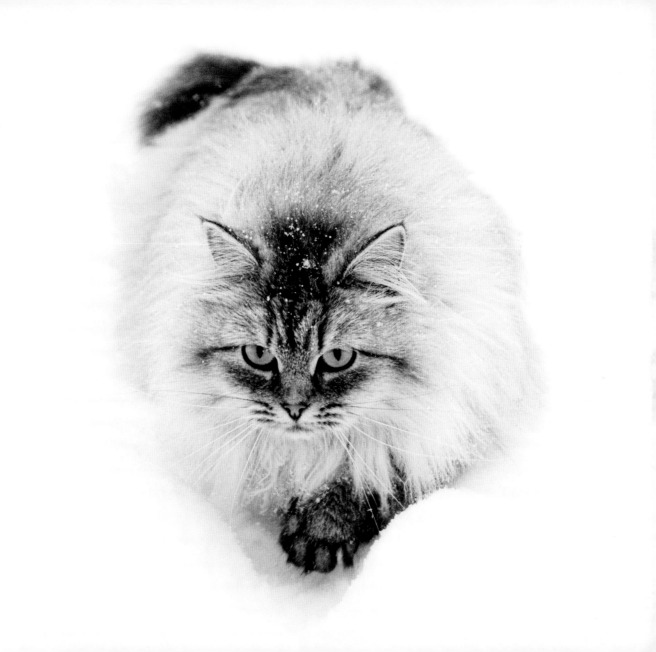

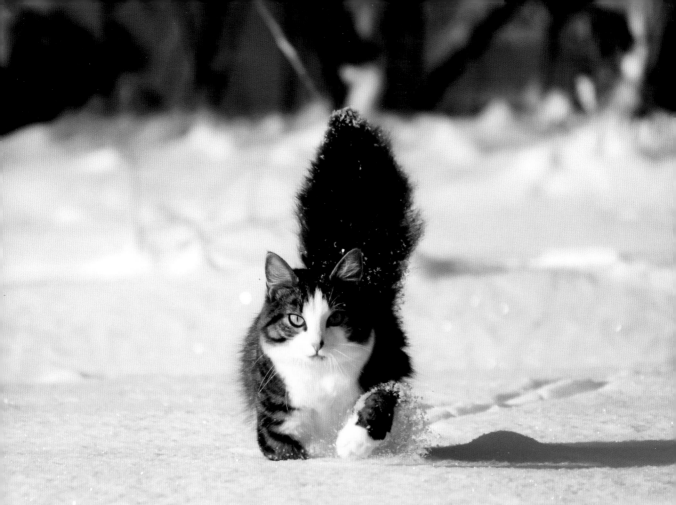

Why does it always snow
whenever I'm running late?!

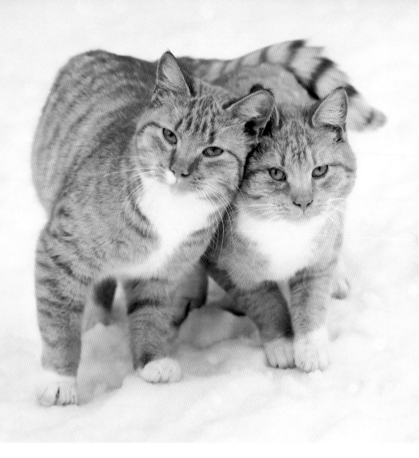

Now, I don't mean to alarm
you, but I think we might be
stuck together

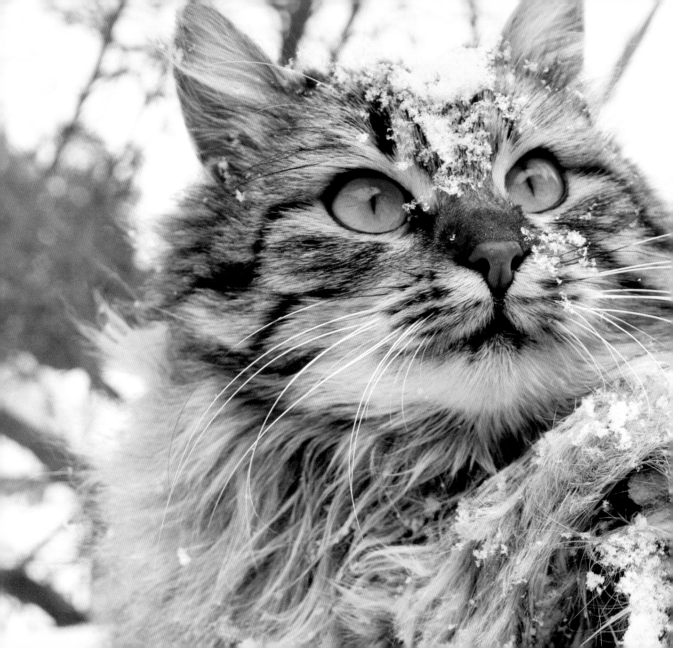

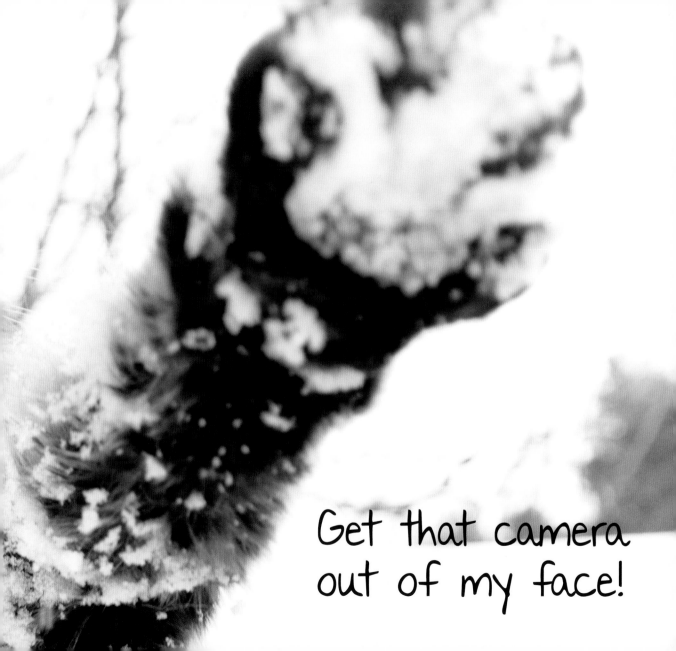

Get that camera
out of my face!

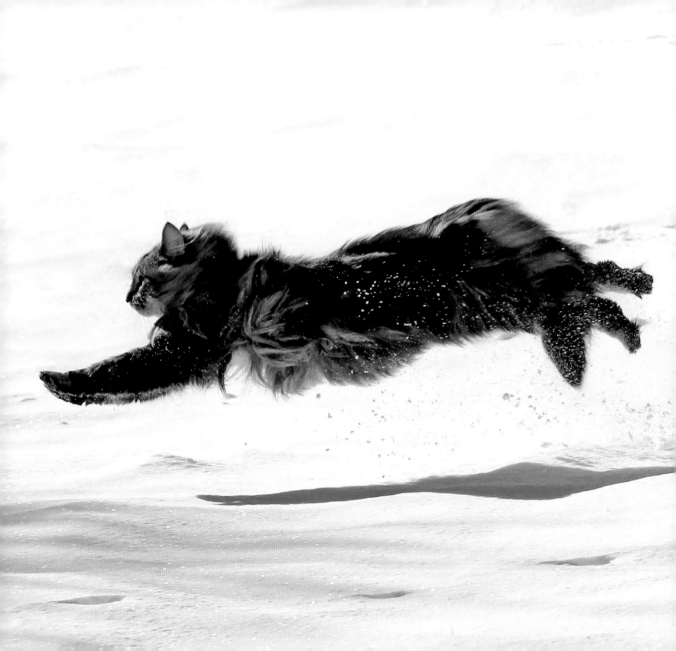

Supercat!

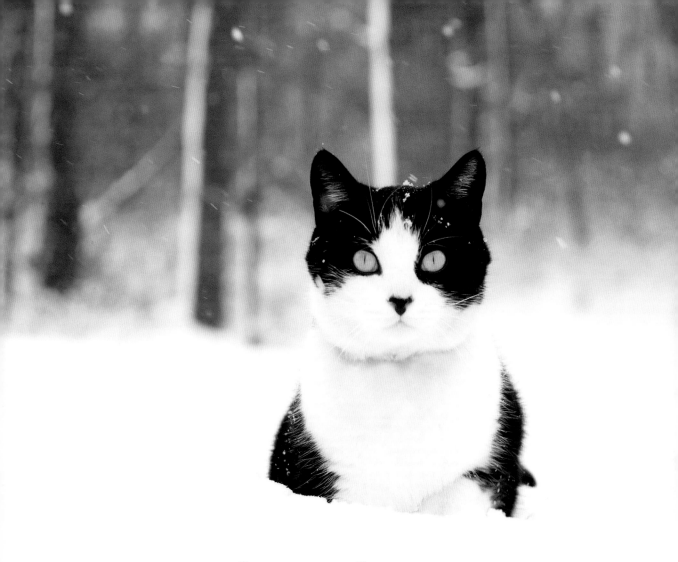

Brain freeze

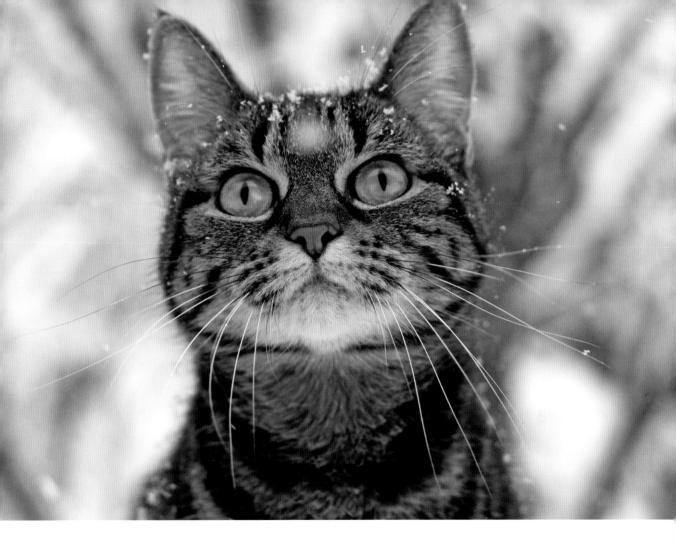

It's just all so beautiful

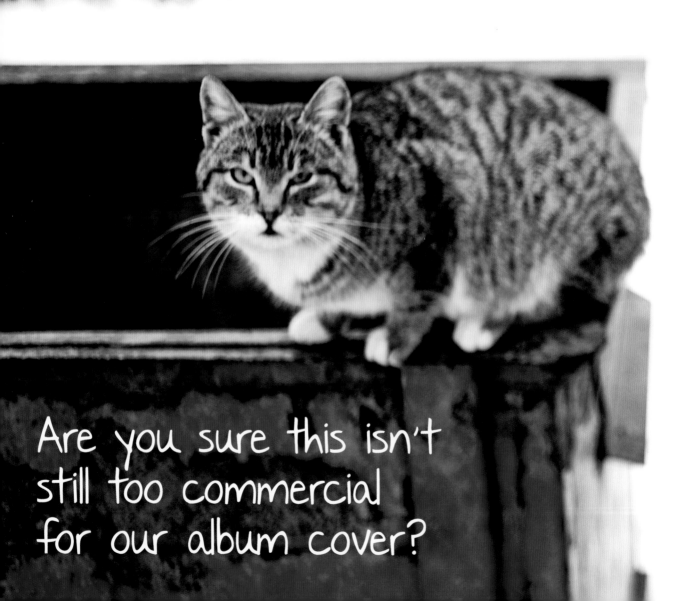

Are you sure this isn't
still too commercial
for our album cover?

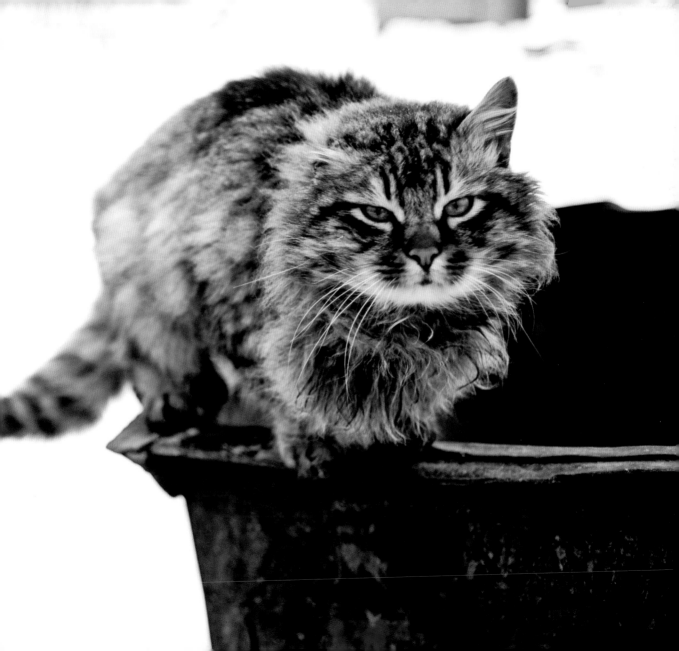

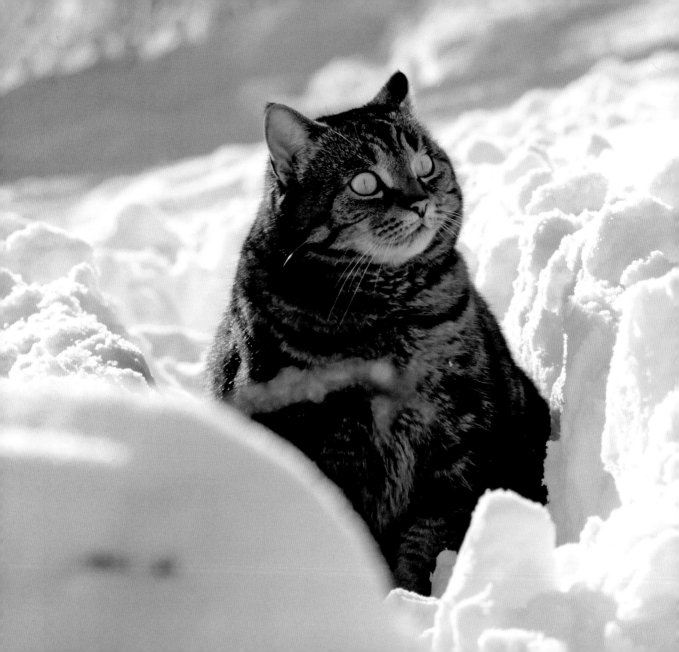

It's going to be a long uphill struggle to regain my beach bod

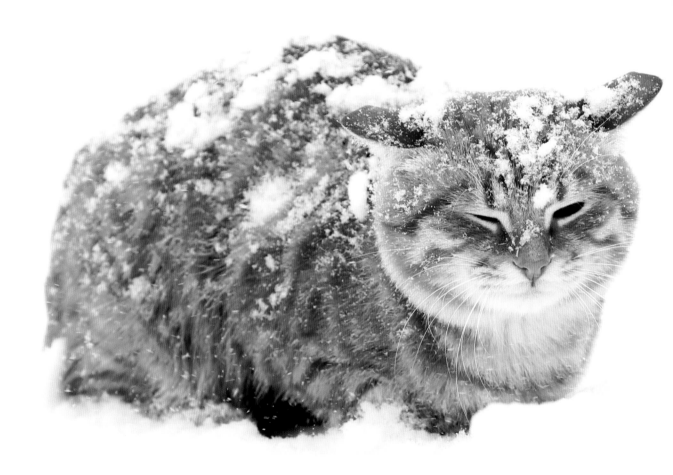

This is NOT fun

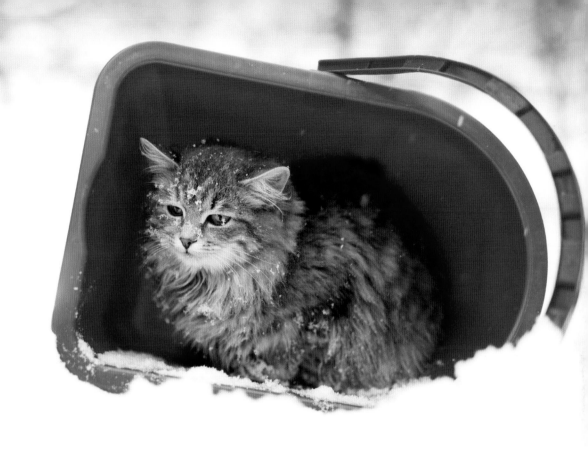

Whilst many cats love it,
the snow is certainly not
for everyone

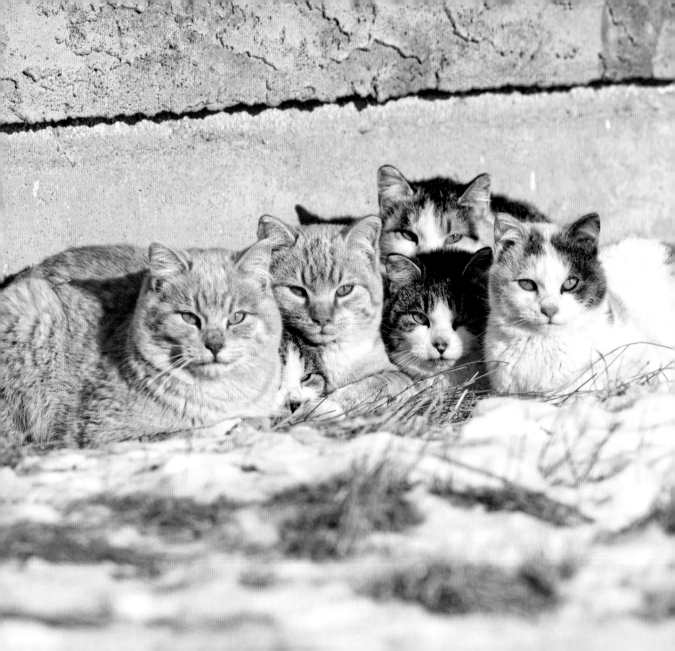

We've all read the survival manual, guys. Huddle for warmth

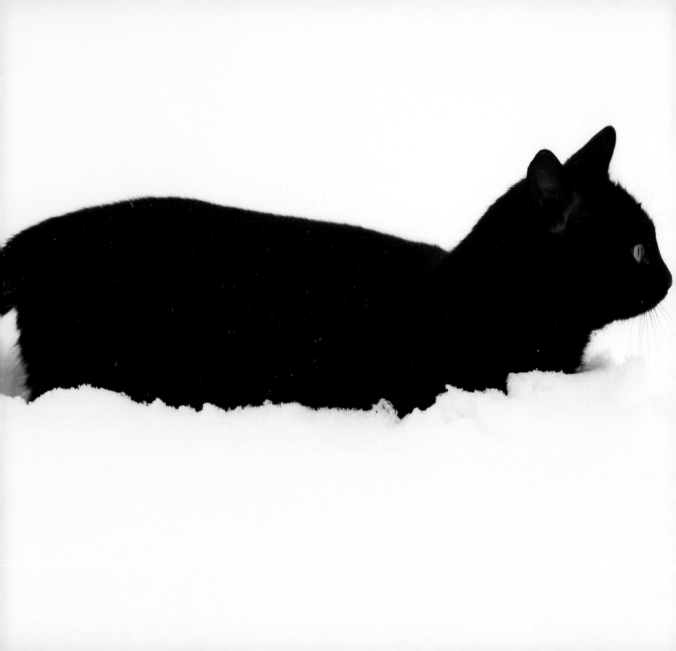

They all said there was no future in being a cat snowplough...

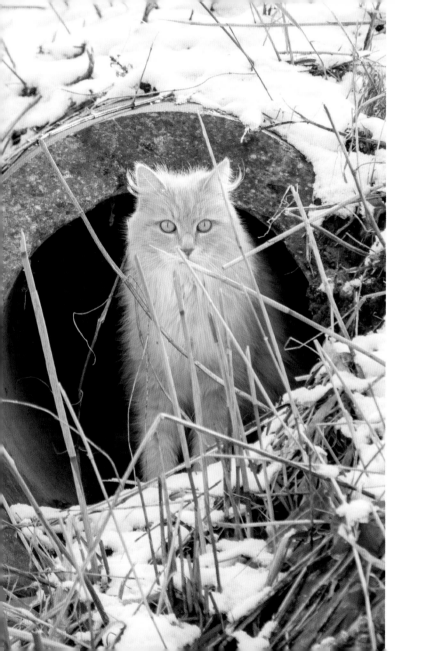

IT WAS
SUMMER
WHEN I
WENT TO
SLEEP!

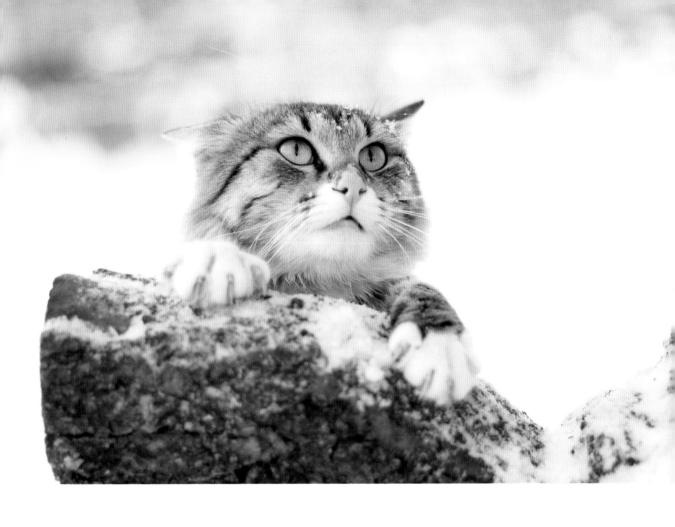

Brother! Help me!

Now, this is
how you look
good naked!

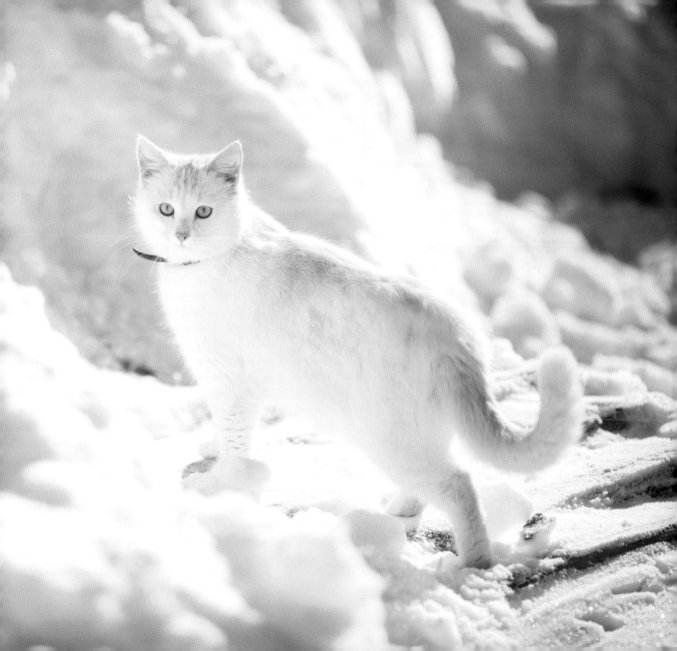

It's like walking in custard - very cold custard

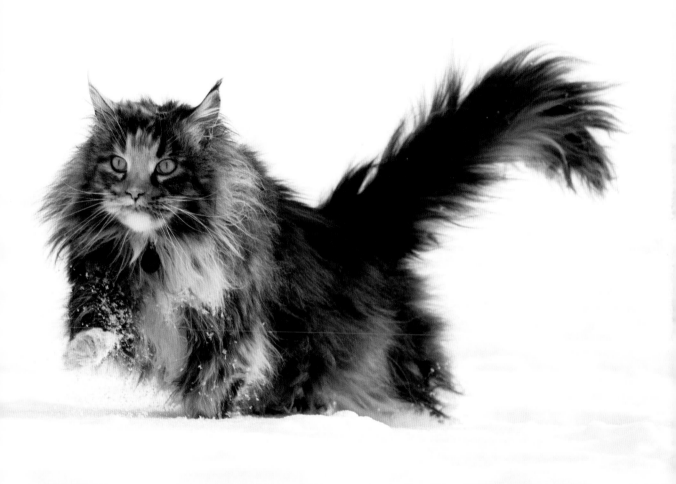

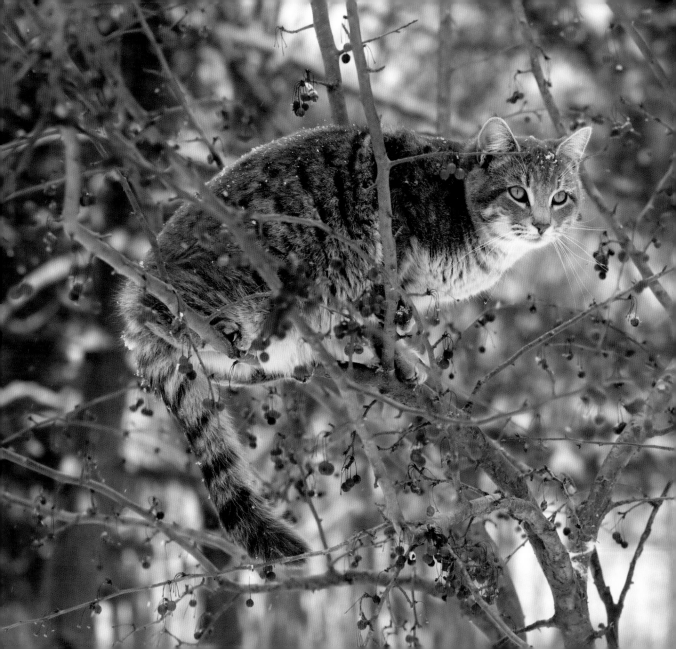

I'm so pretty I could be on a Christmas card!

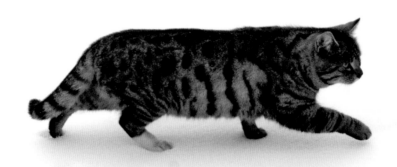

Now, this is what I
like to call cattitude!

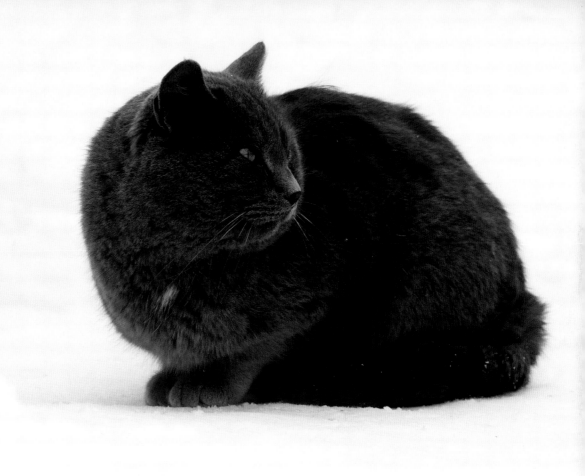

I swear that I will find
something green!

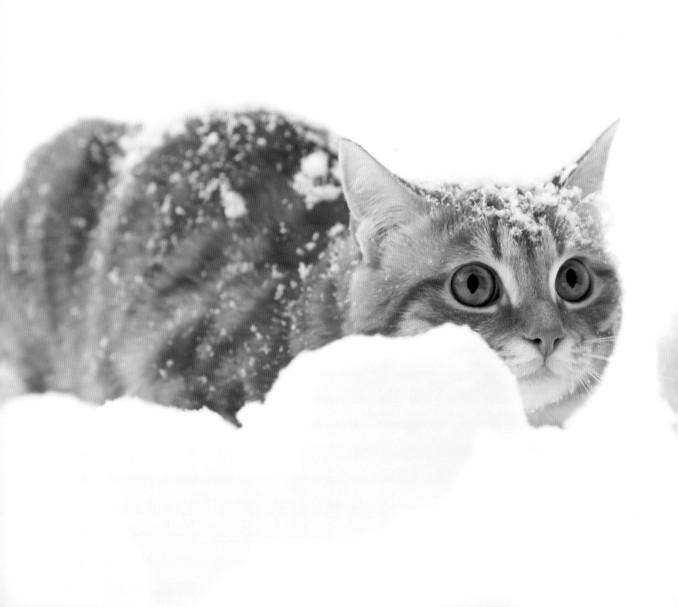

Peekaboo!

Meditate - become
the falling snow

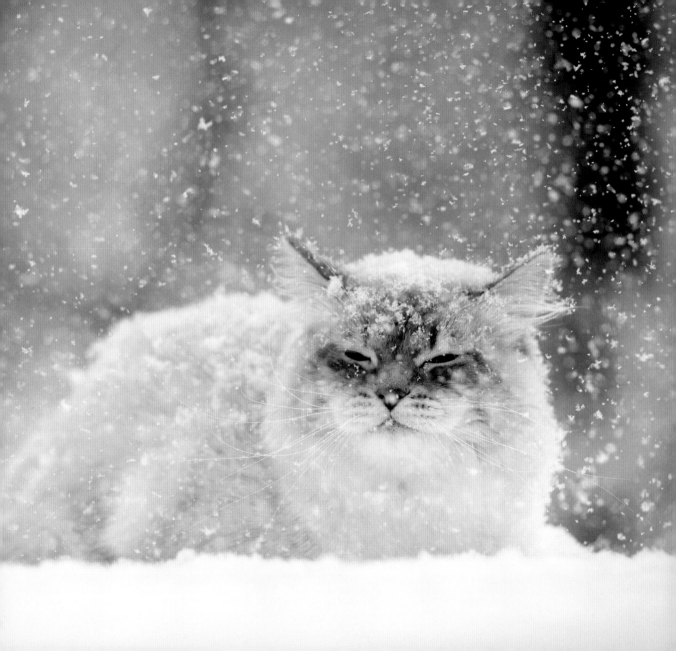

Time to channel my
inner snow leopard

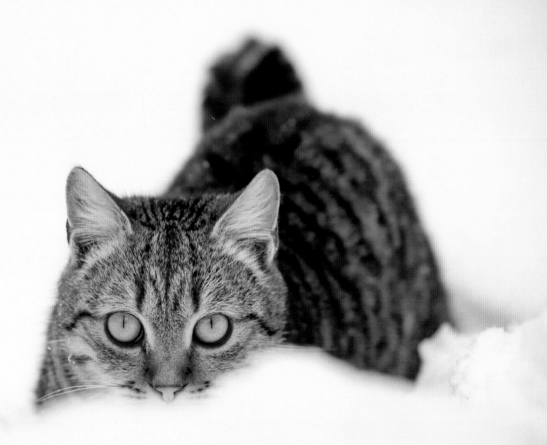

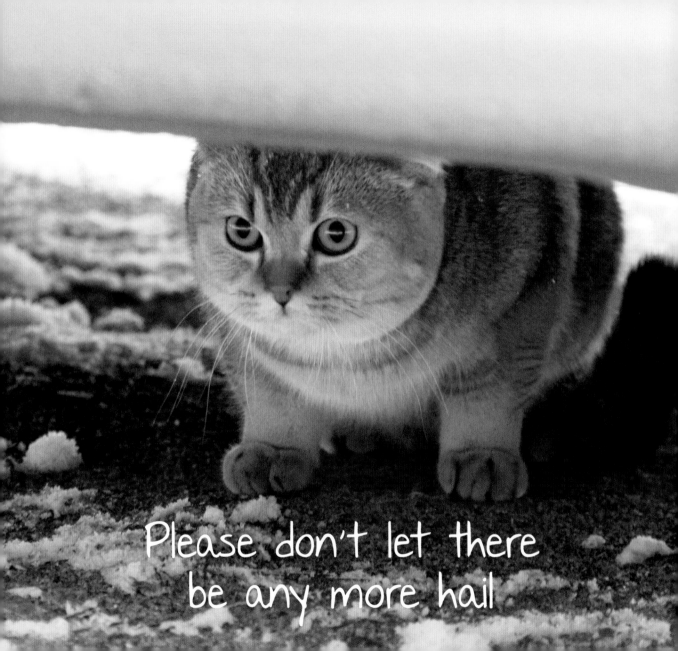

Please don't let there
be any more hail

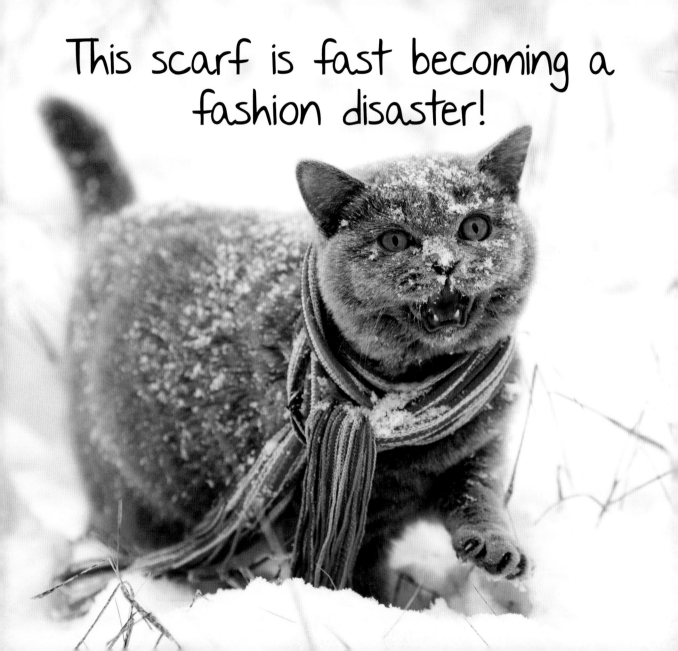

Leave me alone,
I'm hibernating

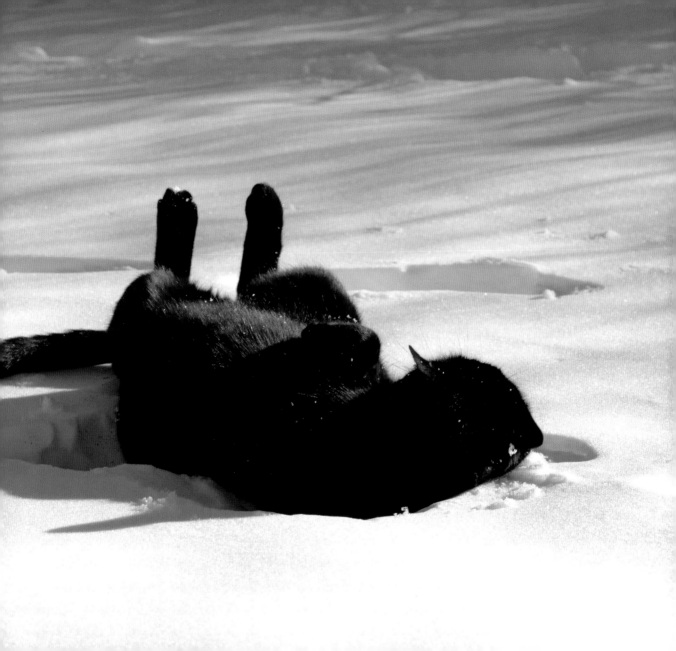

Is someone
making hot
chocolate?

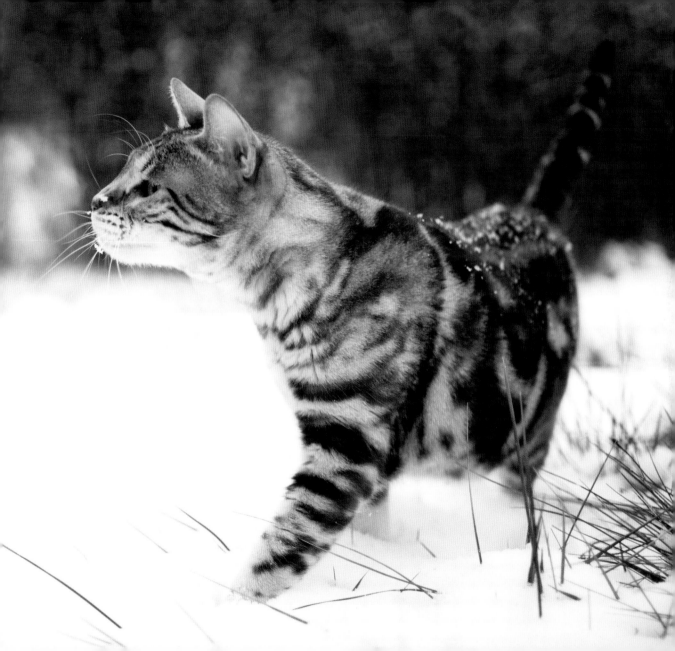

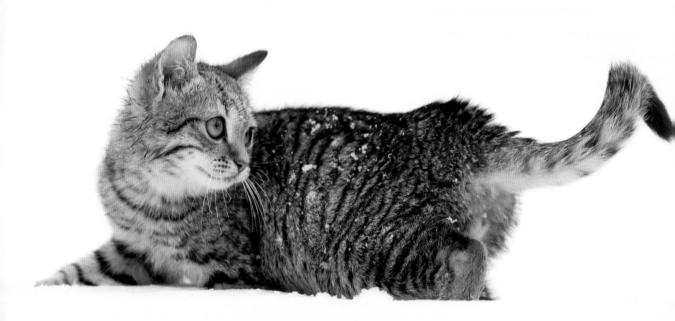

Just five more
minutes outside mum!

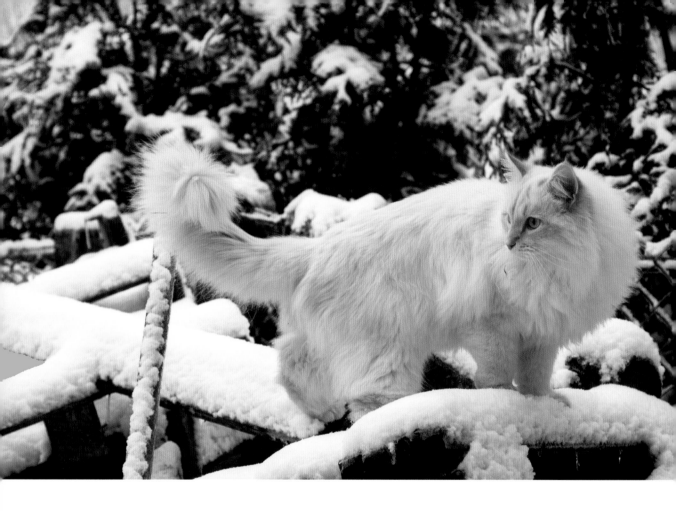

If a cat falls in the woods,
can anyone hear it?

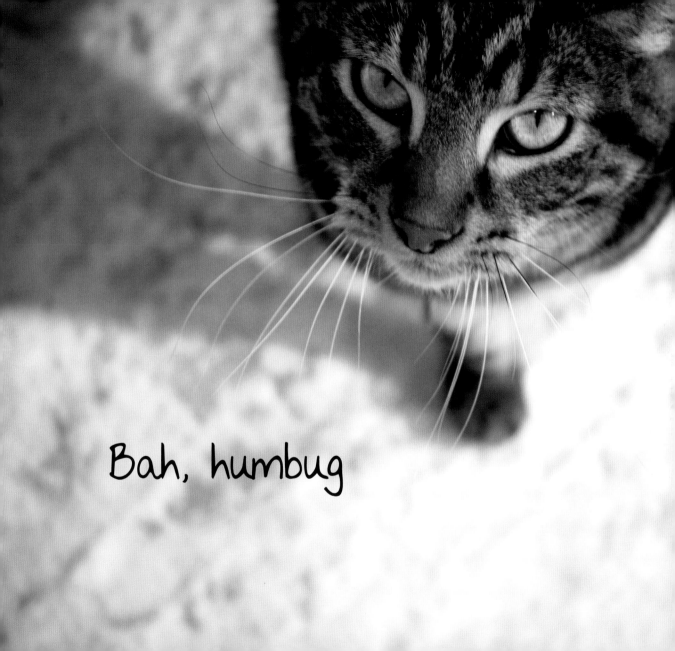

Bah, humbug

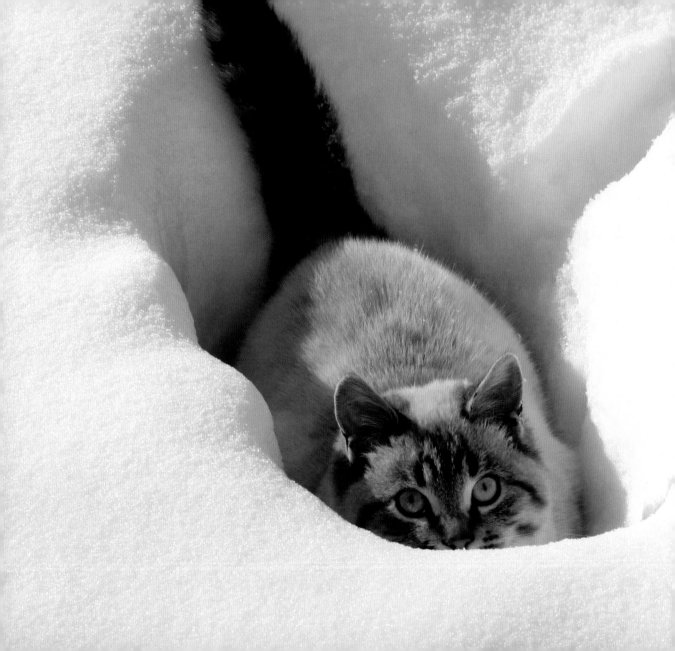

I may have
miscalculated
the depth of
this snow

Who'd have thought that I could be both warm and fabulous at the same time?

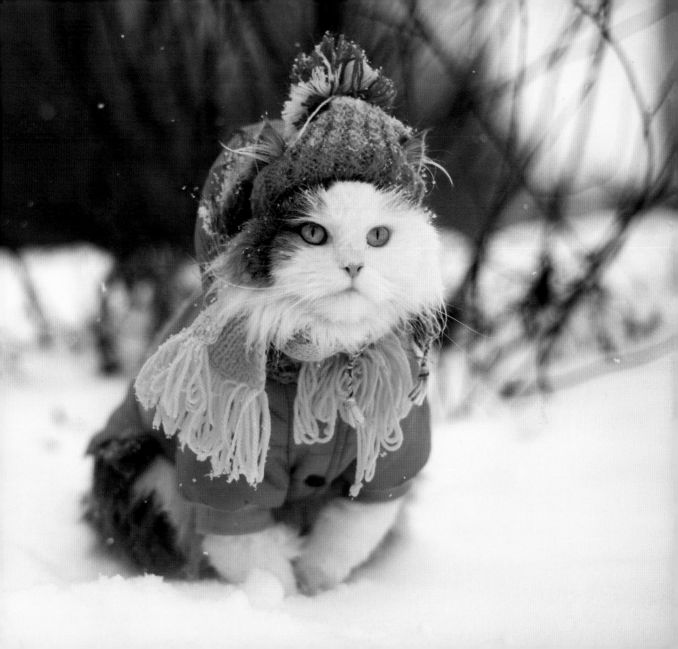

My tongue is 100%
stuck to my nose

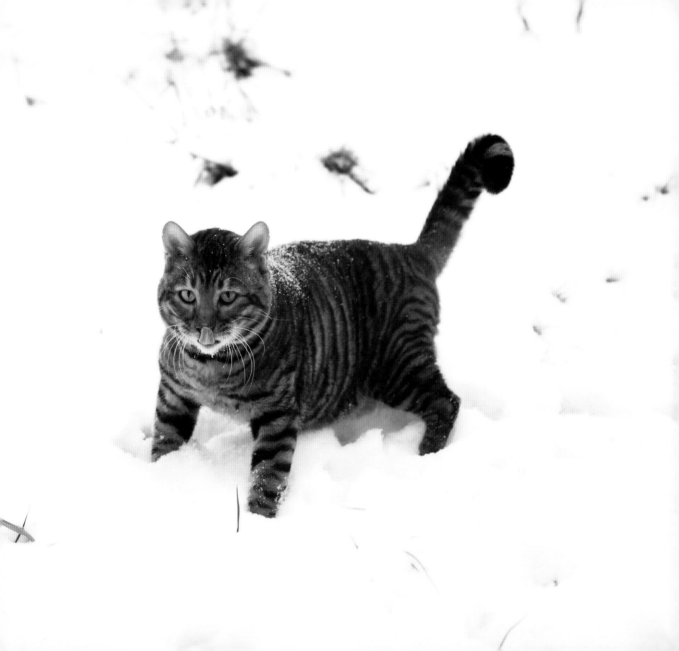

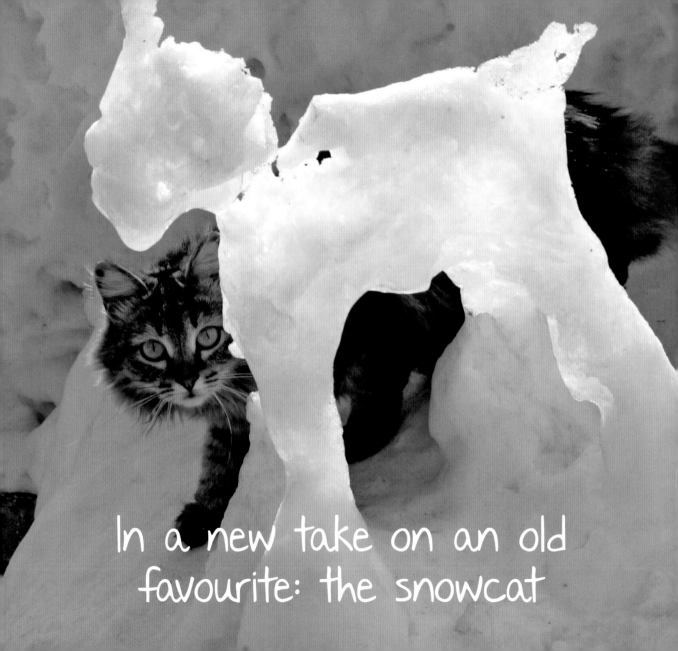

In a new take on an old favourite: the snowcat

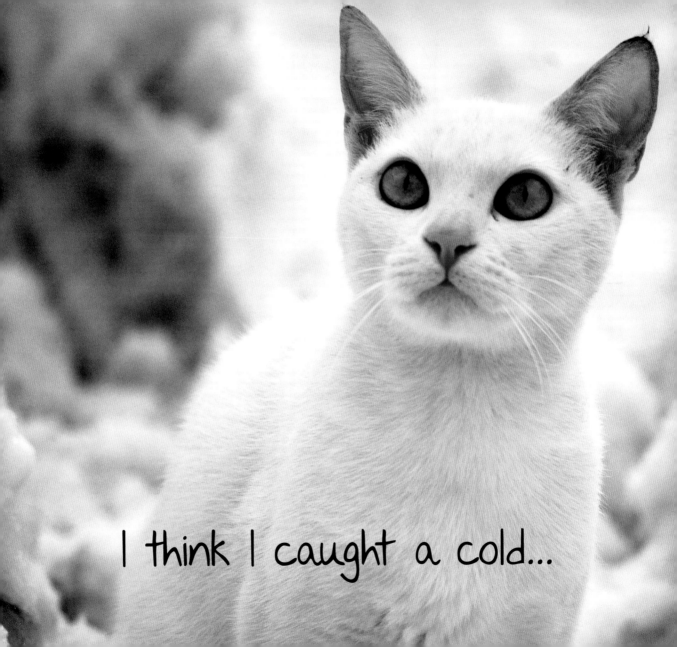

I think I caught a cold...

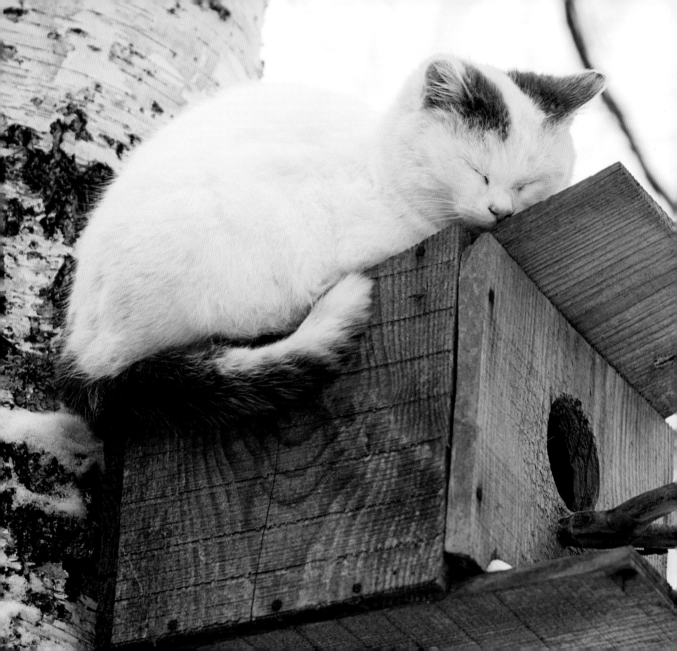

It's very cold...
but one day,
they're going to
come out!

Did you know I got to the final audition for the Snow Queen?

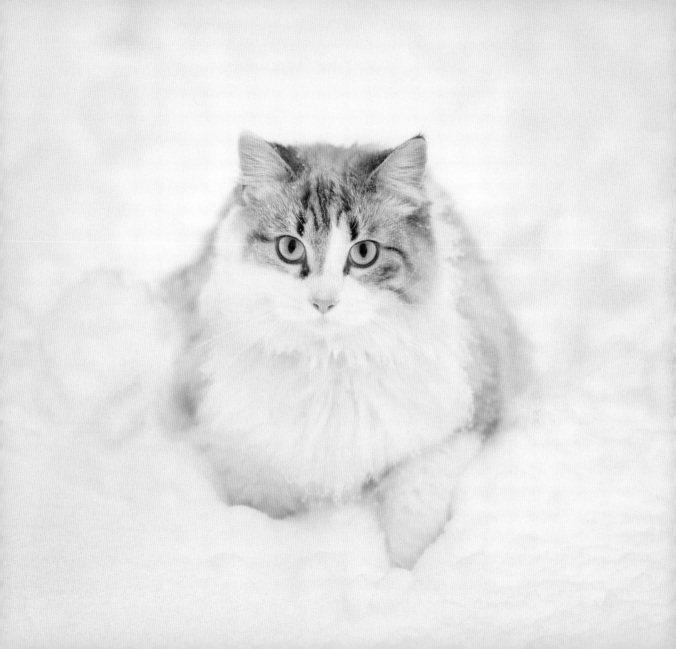

Can you feel your tail?
I'm not sure if I could
feel it before, but I
definitely can't now!

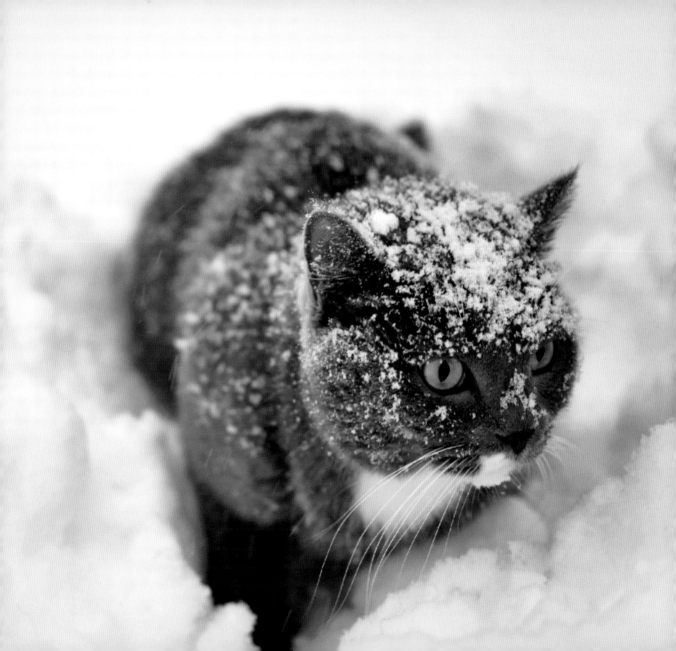

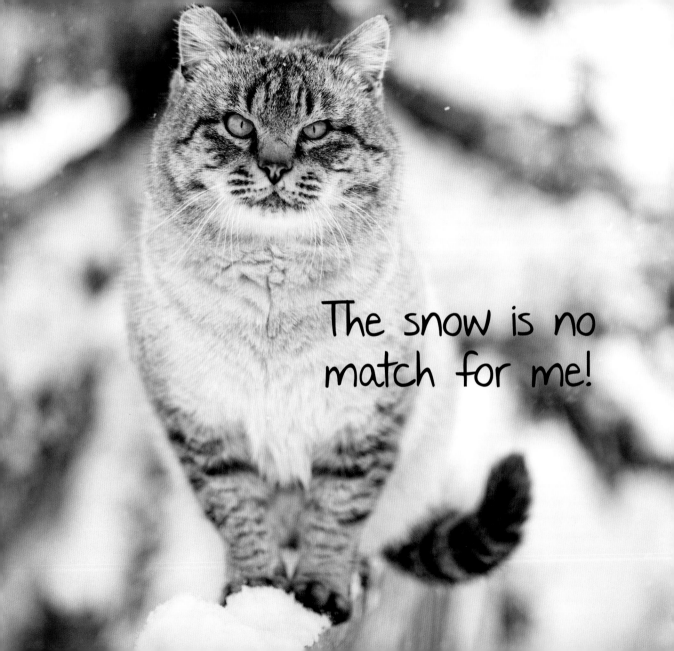

The snow is no match for me!

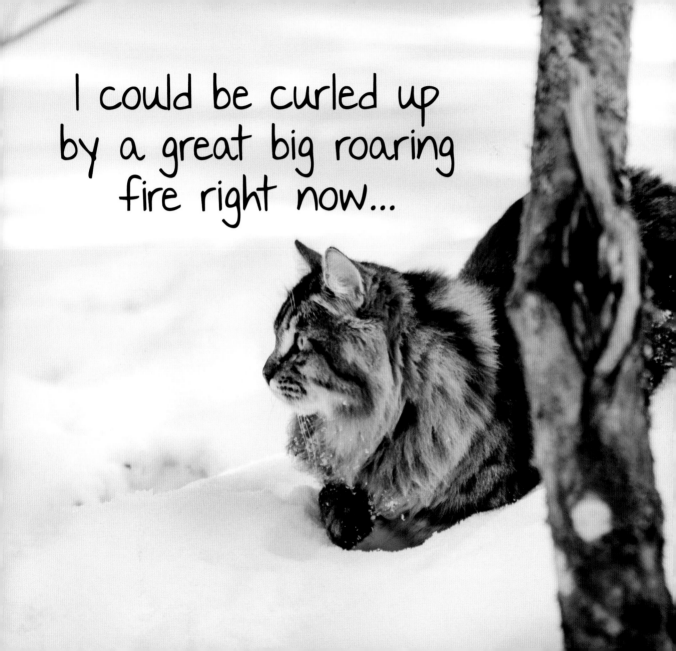

My Nutcracker
audition is coming up!

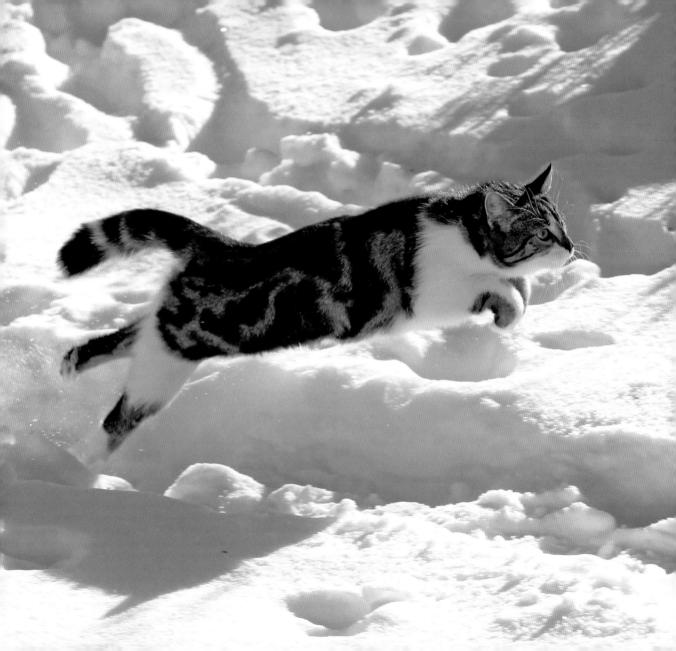

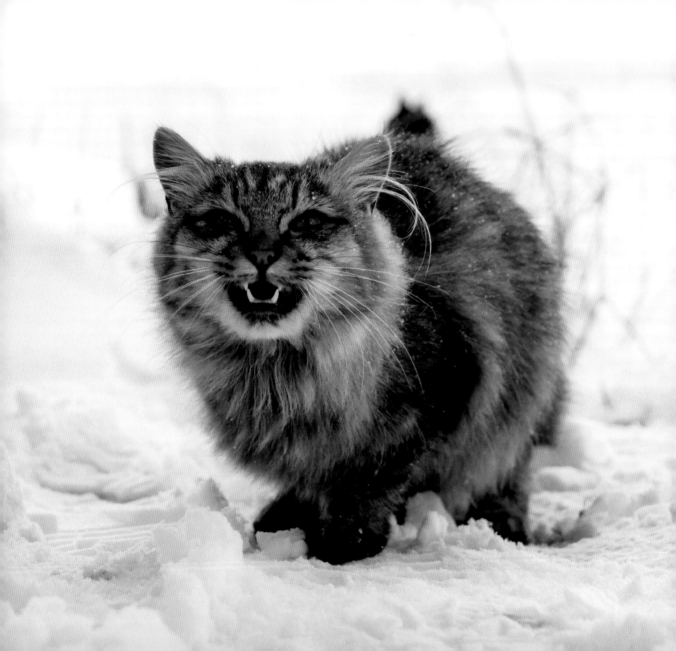

Say cheese!

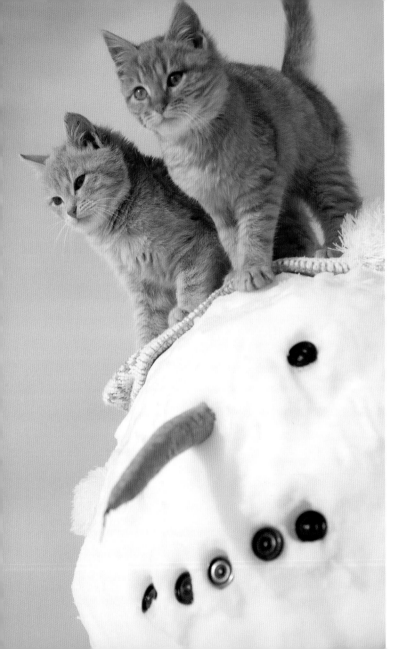

Maybe, just maybe we shouldn't have made the snowman so tall

White to the left, white to right. Yup, I'm lost

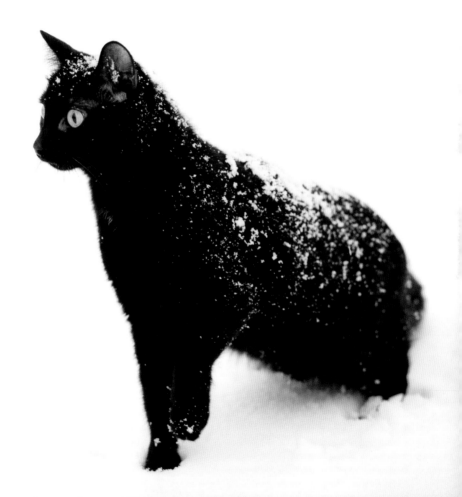

Is this what it comes to? A life defined by cold wet paws?

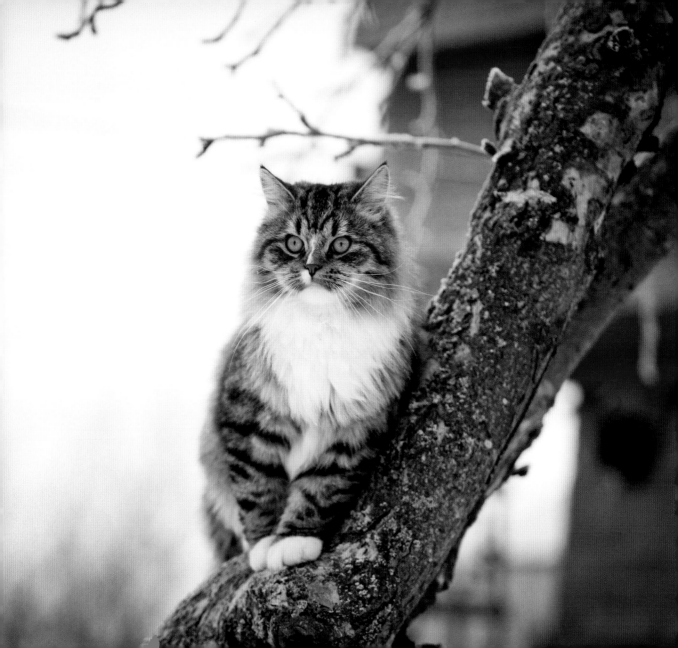

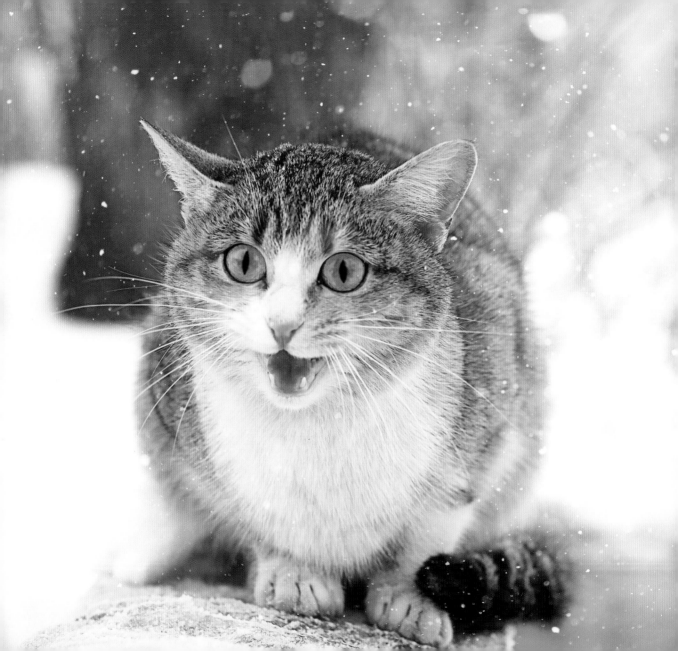

SNOWBALL
FIGHT!

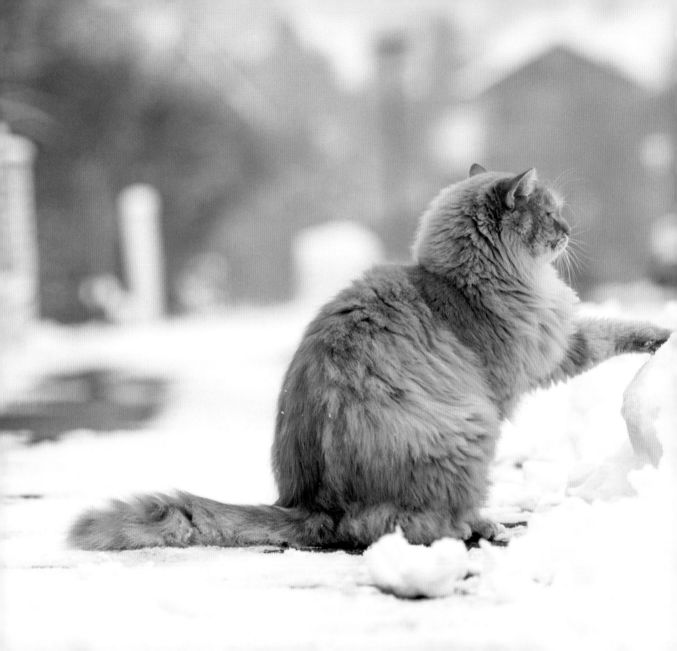

This snow is
gonna melt
before I finish
my sculpture!

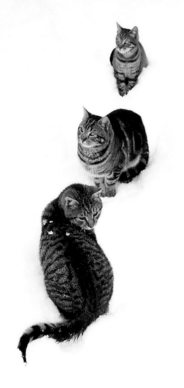

None of us
will be allowed
inside until
the one who
ate the budgie
owns up!

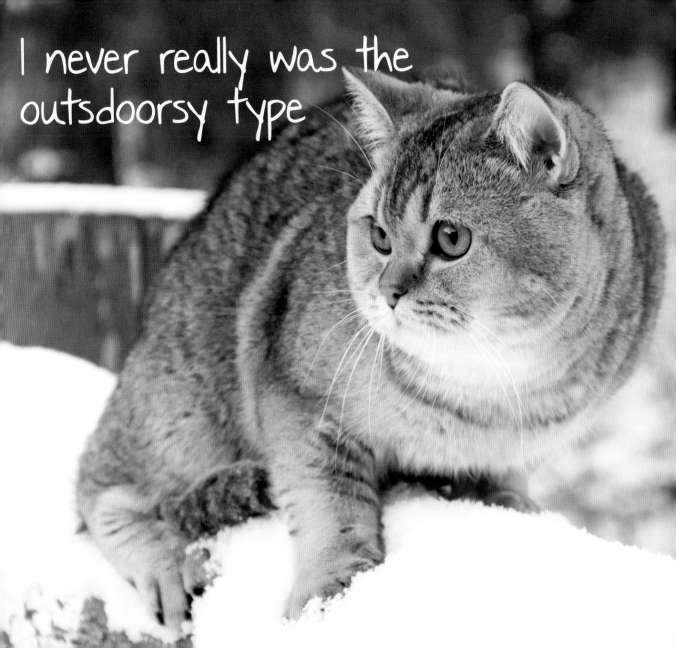

I've been
looking for my
home for hours

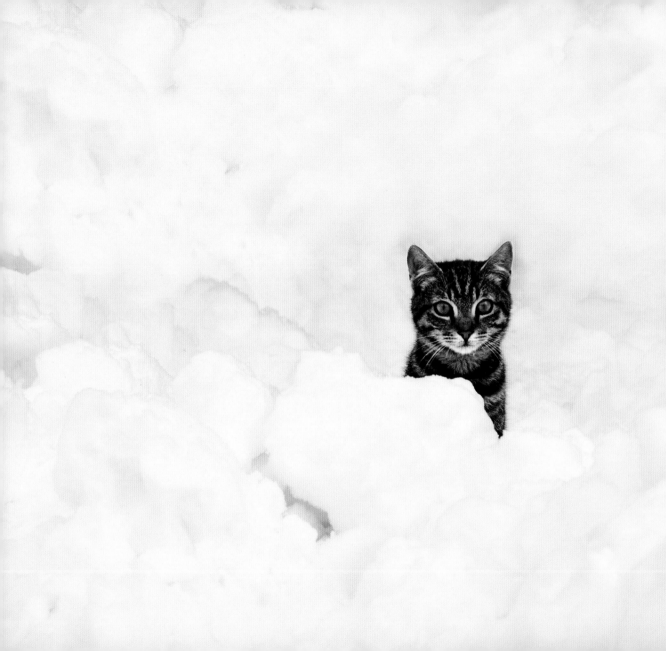

What do you
mean you can
still see me?

My heart is as
cold and hard
as this winter

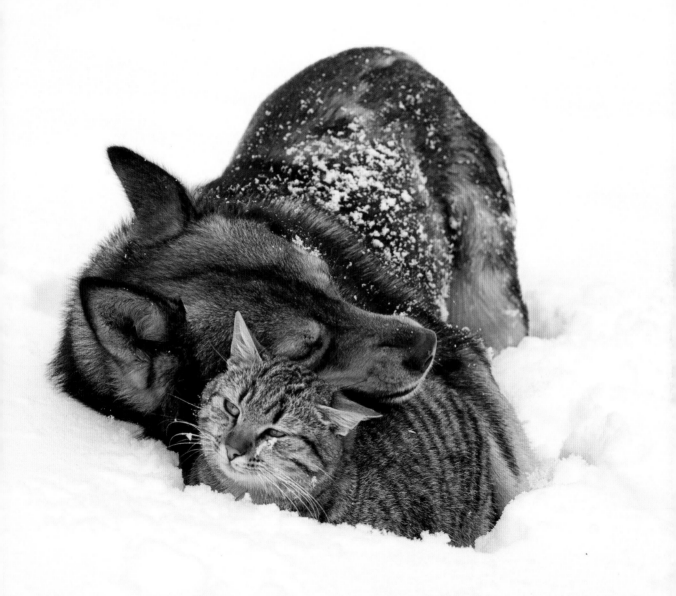

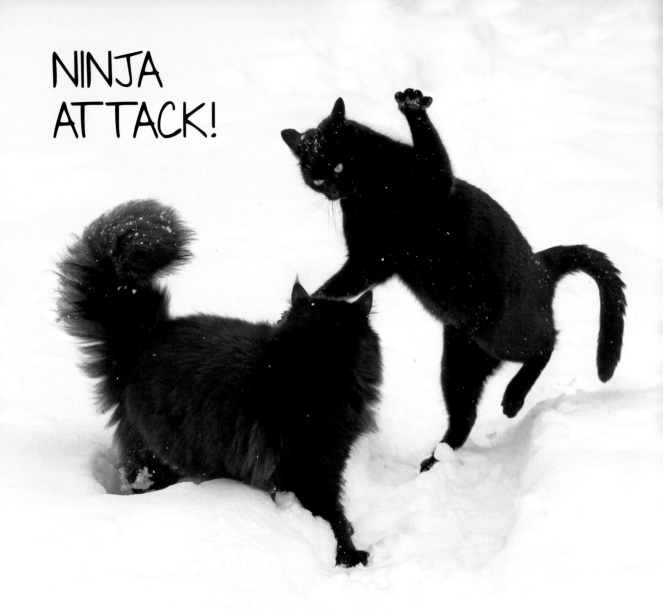

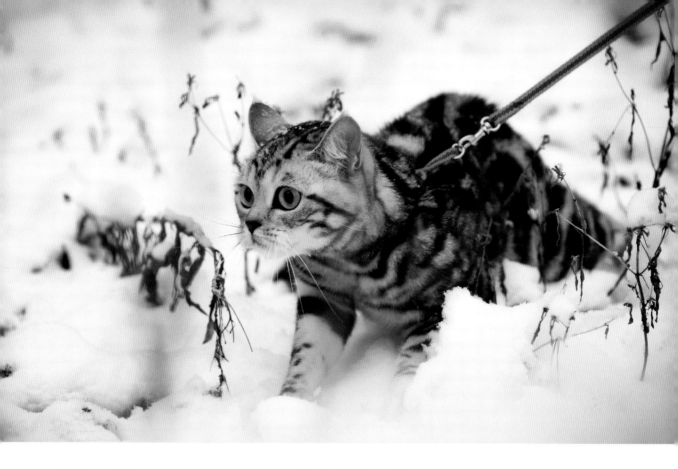

All this snow AND I'm put on a lead. As if I'm no better than a stupid dog...

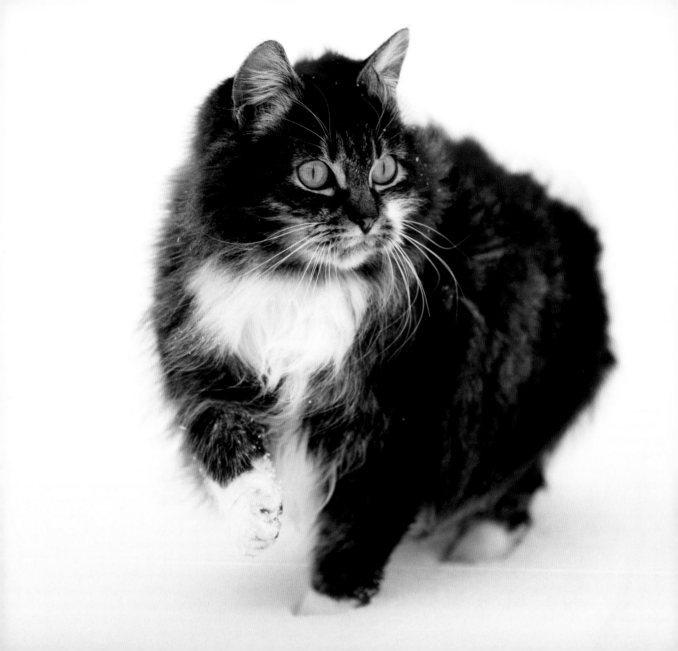

What did you say?
An Autumn-Winter
clearance sale at
the petstore?!

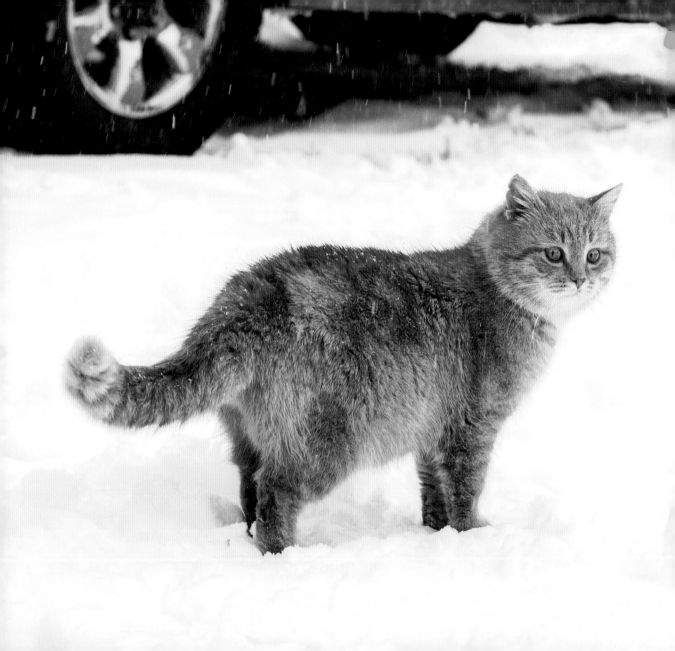

The stress of the festive period is really getting to me

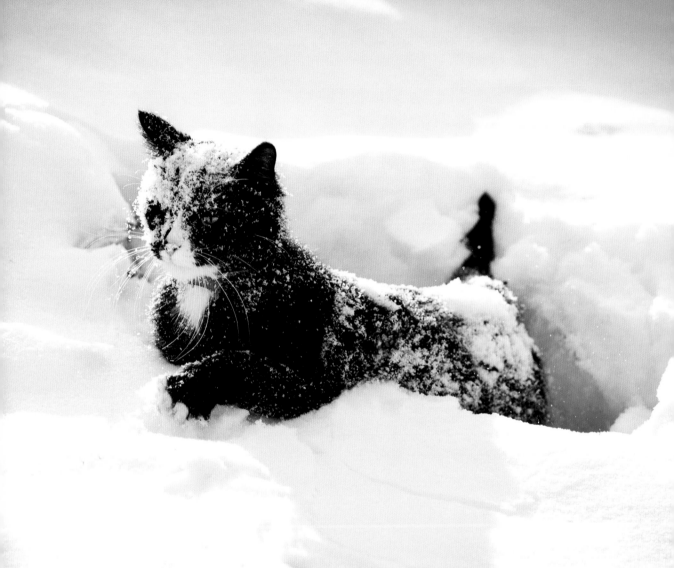

I'm not sure I've quite figured this out yet...

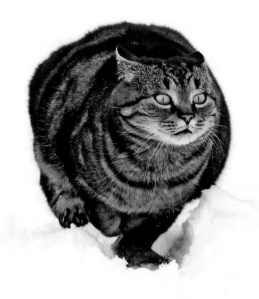

I may have eaten one
too many mince pies
this Christmas

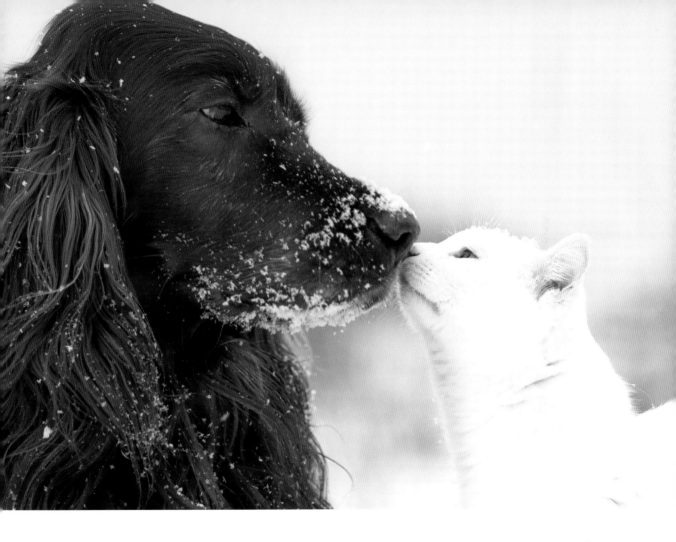

Have you read *Dogs in Snow?*

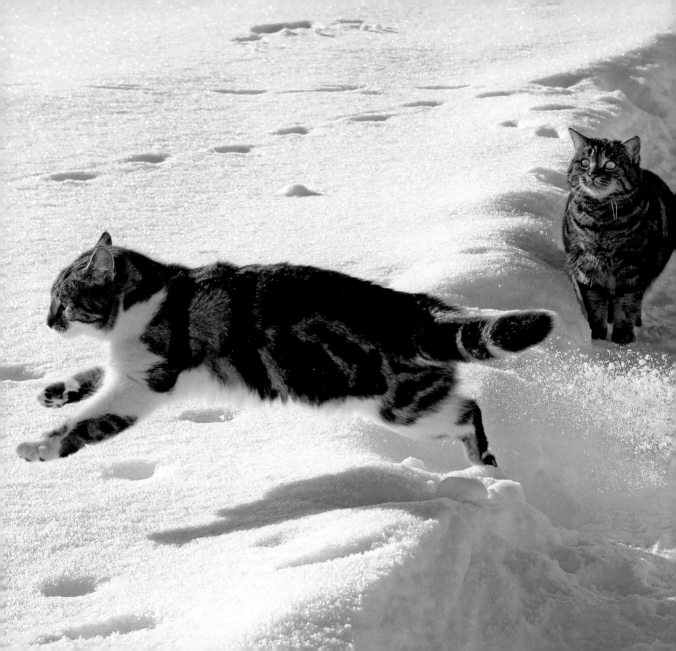

Onwards! To Glory!

I was born
to be wild!

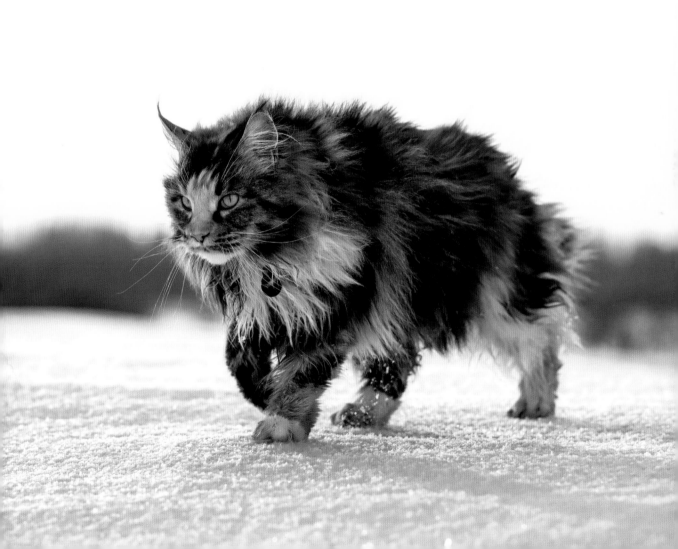

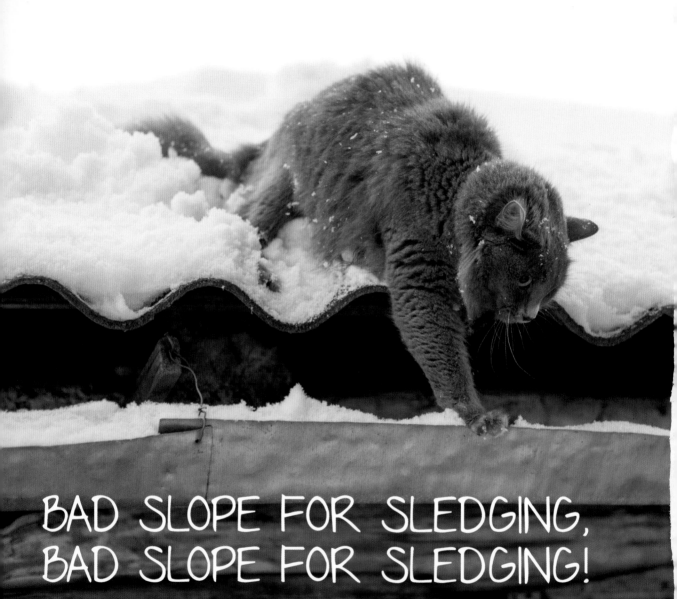

BAD SLOPE FOR SLEDGING,
BAD SLOPE FOR SLEDGING!